CANALETTO

CANALETTO

Christopher Baker

Phaidon Press Limited
2 Kensington Square, London W8 5EZ

First published 1994
© Phaidon Press Limited 1994

A CIP catalogue record for this book is available from the
British Library

ISBN 0 7148 3249 9 Pb
ISBN 0 7148 3207 3 Hb

Printed in Singapore

Cover illustrations:
Front: *The Doge Visiting the Church and Scuola di San Rocco*, *c*1735 (Plate
16)
Back: *London: the Old Horse Guards from St James's Park*, 1749 (Plate 33)

The publishers would like to thank all those museum authorities and
private owners who have kindly allowed works in their possession to
be reproduced. All works from the Royal Collection are © 1994 Her
Majesty the Queen.

Canaletto

In the spring of 1785 the traveller Mrs Piozzi arrived in Venice for the first time, and wrote enthusiastically that '… it was wonderfully entertaining to find thus realized all the pleasures that excellent painter had given us so many times reason to expect'. The 'excellent painter' was Canaletto (1697-1768) (Fig. 1), and her reaction was a common one. Canaletto's many depictions of Venice portrayed that city in such a compelling fashion that generations of visitors to Italy had a picture of Venice in their minds before they actually saw the city.

Canaletto's paintings certainly continue to have this effect, but they also give pleasure for many other reasons. This is perhaps due to his extraordinary ingenuity in creating them. When first looking at his works it is tempting to consider them as simply paintings of what the artist could see – in other words, depictions of, rather than reactions to, his chosen subjects. But once you start to study them in detail it becomes apparent that they are not just descriptive but are in fact far more complex and subtle. Canaletto carefully considered, selected and constructed the views that he painted, and it is the challenge of unravelling this procedure which makes his work so rewarding.

In order to establish how, and indeed why, Canaletto adopted the approach he did it is necessary to consider three particular aspects of his career: the way in which his approach fits into the tradition of cityscape painting, the refinement of his technique, and his relationship with his patrons.

The Venice Canaletto recreated in his paintings is a city with a positive air. He was never concerned with depicting the drudgery of daily urban life, but instead sought to celebrate the qualities he considered unique to the capital of the Serene Republic. He achieved this by studying, and then painting, both the public and the private faces of Venice. The great arenas of civic life – the Grand Canal and Piazza San Marco – were depicted sometimes as showcases for spectacular festivals, but the quiet, out-of-the-way corners and backwaters, far removed from tourist itineraries, were explored as well. This second type of subject matter could perhaps only interest a native of the city such as Canaletto.

Zuane (or Giovanni) Antonio Canal was born in October 1697 and christened in the church of San Lio, a short distance from the Rialto Bridge. He later became known as Canaletto, probably to distinguish him from his father, Bernardo Canal, who was also an artist. Bernardo came from an old Venetian family which, although not of the ruling class, retained the right to use a coat of arms. Bernardo worked as a designer and scene painter for the theatre, and seems to have enjoyed some success; his name was often given greater prominence than that of the composer on the advertisements for operas. Canaletto, together with his brother Cristoforo, initially followed Bernardo, and was himself employed as a *pittore da teatro* (theatrical painter). This type of work may seem an inauspicious start for his career, but it provided

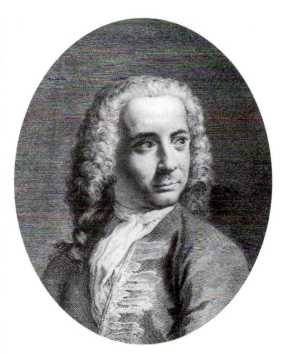

Fig. 1
ANTONIO VISENTINI
Giovanni Antonio
Canal, called
Canaletto (detail)
Before 1735. An engraving
after G B Piazzetta for the
title page of *Prospectus
Magni Canalis Venetiarum*

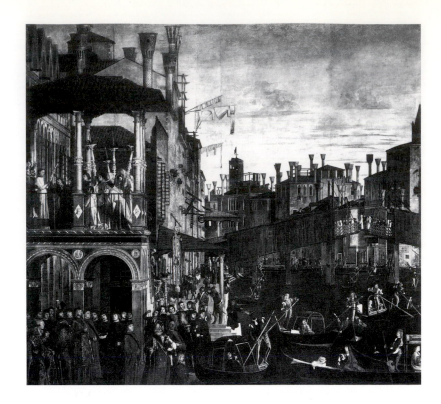

Fig. 2
VITTORE CARPACCIO
The Miracle of the
Legend of the True
Cross (detail)
*c*1500. Oil on canvas,
365 x 389 cm.
Accademia, Venice.

Canaletto with skills which he could later put to good use in his independent pictures, and locates him precisely for us in what was artistically an exciting and vibrant environment.

Venice at this time was no longer a powerful force in international politics, but it had developed a potent reputation as a city of pleasure. It became renowned across Europe for its diversions: for courtesans, coffee houses and gambling dens, as well as the theatre, opera and its famous Carnival. The success of many of these entertainments depended on the effective creation of scenery, props, costumes and floats, and the production of them kept an army of craftsmen, seamstresses, designers and painters fully occupied. Canaletto helped his father design backdrops for several productions, including works by the composers Vivaldi, Chelleri and Pollarolo. Unfortunately, though, no evidence of this early work has been found. It would, however, be reasonable to assume that these projects involved the application of linear perspective. This gave the impression that the set extended far beyond its actual boundaries, and was usually used for dramatic architectural scenes. This type of visual trick had formed an important part of such work since the Renaissance; the architect Andrea Palladio (1508-80) developed the technique brilliantly in the sixteenth century, and in Canaletto's own day the Bibiena family of theatrical designers were particularly notable adherents. It can be no accident that Canaletto, whose early work probably involved manipulating these perspectival schemes, should later create paintings noted for their spatial clarity. It would be too simplistic to say that in his mature works Canaletto treated the whole city as a stage set, but reasonable to suggest his familiarity with theatrical effects meant he could shift viewpoints, balance compositions and adjust lighting arrangements with ease.

The theatre may have seemed seductive at first, but it appears that Canaletto soon tired of it. In 1719 he travelled with his father to Rome where he helped with the preparations for two operas by Scarlatti, performed during the Carnival in 1720. This trip seems to have marked a turning point for the young artist. The biographer Zanetti

wrote in 1771 that on the journey south Canaletto 'solemnly excommunicated, so he said, the theatre', in order to spend all his time 'painting scenes from life'. This dramatic description spices up his biography, but probably bears little relation to the actual nature of this change of direction. What is more likely is that Canaletto had already started painting a few independent works, and that his experience in Rome clarified his intention to continue. In Rome he could have come into contact with artists such as Gian Paolo Pannini (1691/2-1765), who produced *vedute* (view paintings) related to the type of images he was later to specialize in executing. There is some evidence to suggest that while there Canaletto also made a number of drawn studies of ancient sites which were used as the basis for later works.

The start of Canaletto's career in this new vein – as a view painter – was marked in 1720 when, back in Venice, his name was first recorded in the register of the city's professional painters' guild. The fact that he chose to depict his immediate surroundings was not in itself something new. Memorable painted images of Venice can be traced back as far as the fifteenth century and the work of artists such as Vittore Carpaccio (active 1490-1523), who used the city as inspiration for the fantastic backgrounds in his large narrative paintings (Fig. 2). Anecdote and detail in these works mark them as ancestors of Canaletto's pictures, but there are also notable differences between these early works and the creations of the eighteenth-century master. While for Carpaccio the city was a context for the subject, in Canaletto's works the city itself became the subject. This shift in emphasis can be traced through the fifteenth to the eighteenth century, during which landscapes and cityscapes increasingly acquired independent status, slowly being deemed worthy in their own right of an artist's attention. The process was bound up with the gradual secularization of art, and the consequent expansion of the range of subjects explored by painters.

Fig. 3
VANVITELLI
Piazza San Marco:
looking South
*c*1690s. Pen and ink on
paper, 47 x 77 cm.
Biblioteca Nazionale,
Rome

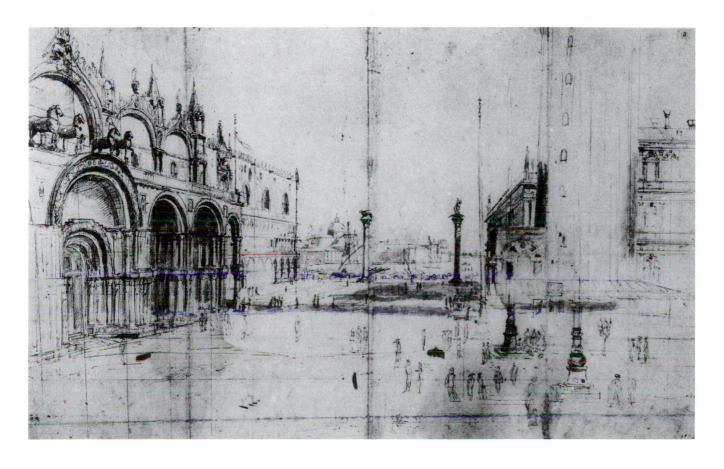

7

During the seventeenth century Rome had been the main centre in Italy for innovation in landscape painting. Artists such as Annibale Carracci (1560-1609), Nicolas Poussin (1594-1665) and Claude Lorraine (1600-82), who all worked there, developed a form of ideal landscape which was to influence many later painters. But cityscapes rarely formed part of their work. To find any quantity at this period you have to look instead to the Netherlands, and the work of artists such as Jan van der Heyden (1637-1712), who executed meticulous depictions of Amsterdam, with its buildings quietly reflected in the canals.

A number of Dutch and Flemish artists travelled to Rome in search of the inspiration, fabled light, and patronage which it was thought could be found there. Among them was Gaspar van Wittel (1653-1736), who through his choice of subjects seems to have been a particular influence on Canaletto. Vanvitelli, as he was called in Italian, arrived in Italy in 1672, and lived and worked there until his death. He was employed principally in Rome, but also applied the interest in view painting developed there to the Venetian scene, where he drew views of the city in the 1690s (Fig. 3), which were to form the basis of attractive works in oil. Such views became in turn the specialization of a slightly younger Italian artist, called Luca Carlevaris (1663-1730), who was to prove even more important in paving the way for Canaletto's achievements. Carlevaris was responsible for creating the widespread taste for Venetian view painting, later capitalized on by Canaletto and his great contemporary Francesco Guardi (1712-93). Other aspects of Carlevaris' career also prefigure that of Canaletto; like Canaletto, Carlevaris worked as a print maker as well as a painter, and notably painted for English patrons. It would be wrong to suggest, however, that Canaletto simply took advantage of a set of circumstances and ideas established by Carlevaris; ultimately he was by far the more accomplished painter, particularly in terms of his instinctive and lively use of colour. Canaletto did, however, on some occasions borrow ideas for compositions from Carlevaris: the menacing skies of early Canaletto works perhaps owe a debt to Carlevaris' creations (Fig. 4). The two

Fig. 4
LUCA CARLEVARIS
Entry of the Earl of Manchester into the Doge's Palace
1707. Oil on canvas, 132 x 264 cm. City Museum and Art Gallery, Birmingham

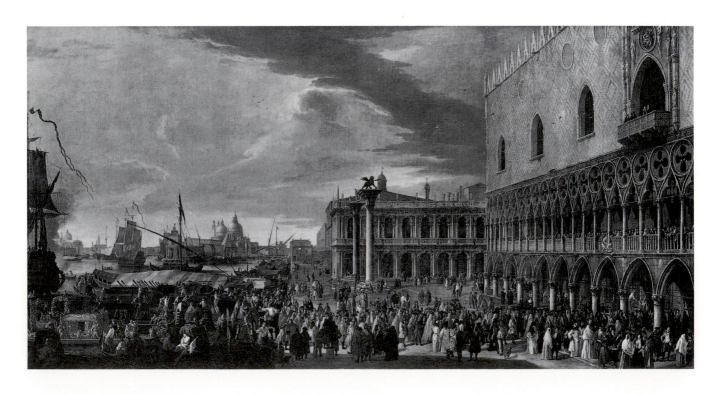

men may well have met, but it is unlikely that they enjoyed a master/pupil relationship.

The status of the type of paintings produced by Carlevaris, and later by Canaletto, requires some consideration. At the time there was a theoretical distinction between landscape painting and view painting, which meant far more than just the difference between rural and urban subject matter. Landscape painting, as practiced by the seventeenth-century Roman masters, was thought to involve the transformation rather than imitation of the natural world, inspiring both the intellectual and poetic sensibilities of the viewer. By contrast view painting, or prospect painting as it was called in England, had a less lofty intention, being mainly topographical and concerned with recording the appearance of buildings. By implication its creation was a less skilful and more mechanical process.

These distinctions, however, are too rigid, as landscape painting relies at its root on observation, and conversely the effective creation of view paintings draws on refined artistic and imaginative skills. Awareness of this balance is central to any appreciation of Canaletto's work.

Within this tradition of view painting Canaletto explored different forms. He created *vedute esatte* (precise views), and on a number of occasions *vedute ideate*, or *di fantasia* (imaginary or fantastic views), which are also known as *capricci*. The term *vedute esatte* (describing the majority of his four hundred-odd paintings), is quite deceptive. It implies exact and descriptive pictures, but Canaletto almost always improved on what could be seen in order to engage the viewer; he allows us to see impossibly wide panoramas, does not shy away from moving or omitting either architectural details or whole buildings if the result is more pleasing, and employs numerous devices to enrich our perception of details of colour and texture. By contrast, in the *capricci*, the explicit intention is to create something imaginary (see Plate 25). Following the example set earlier by painters such as Marco Ricci (1676-1729), in these works Canaletto draws together architectural subjects from different sources and places them in a new arrangement with wit and ingenuity, in order to delight and tease an informed collector. Pictures of this type assume knowledge of their subjects on the part of the viewer, and were designed to appeal to the contemporary taste for ruins and the nostalgia they evoked (see Plate 23).

The earliest works generally considered to be by Canaletto, the so-called Liechtenstein paintings (see Plate 1), are *vedute esatte*, accurate views of recognizable sites, embellished with a degree of poetic licence. They are dated to before 1723, and are so assured that they must have been preceded by other studies of Venice. Various surviving paintings and drawings have been suggested as Canaletto's earlier experiments; it has been claimed that he made a number of drawings in Rome in 1719, and that he painted *capricci* during the first years of his independent activity as an artist. But scholars cannot agree as to whether these pictures are really by Canaletto, and so it remains safer to begin an account of his career with works about which there is no dispute.

It is often the case that an artist grows in stature, and develops towards the masterpieces of his or her maturity, but Canaletto was rather perverse in this respect, because many see his greatest pictures as being among these first paintings (see Plates 1, 2 and 3). They are characterized by moody skyscapes, a sense of foreboding, and an eye for the picturesque qualities of crumbling architecture. These features might imply Canaletto specifically intended local collectors to find

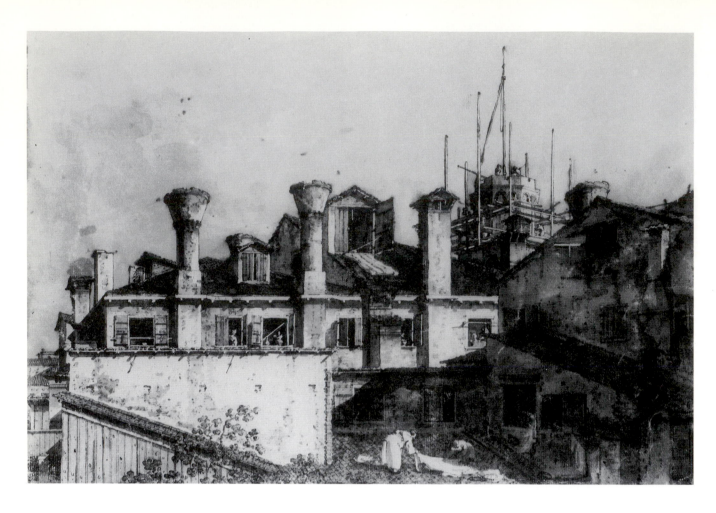

Fig. 5
Roofs and Chimneys
in Venice
*c*1730s-1740s. Pen and
ink with wash on paper,
30.3 x 43.8 cm. British
Museum, London

them attractive. They seem also to reveal glimpses of a powerful and restless individuality, often later smothered by pandering to the demands of the art market.

Canaletto slowly moved on to create images that are more serene in tenor, among which his painting known as 'The Stonemason's Yard' (Plate 8) stands out because of its exceptional quality. Painted in the second half of the 1720s, it is a depiction of a simple and at first glance uninspiring scene – a quiet *campo* (or small square) away from the famous sites. On closer examination, however, the picture reveals an extraordinary range of fascinating details. In it the artist has analysed and lovingly recorded the light falling across a multitude of different textures and architectural shapes, and in so doing seems to have converted the ordinary and everyday into objects worthy of contemplation. Similar motivation can be observed in some of his later sketches in pen and wash (see Fig. 5), in which unpretentious views of rooftops become complex and almost abstract studies of tone and form.

'The Stonemason's Yard' is not recorded before 1808 and so we do not know whether it was commissioned or painted for one of the public exhibitions regularly held in Venice. Canaletto used these exhibitions on at least one occasion to promote his work – he is recorded as having hung a view of the church of Santi Giovanni e Paolo (probably Plate 5) at the annual display of paintings mounted outside the Scuola di San Rocco. The work in question was said to have 'made everyone marvel', and it was purchased by the Imperial Ambassador to Venice, while the exhibition was later depicted by the artist in the background of his magnificent portrayal of the Scuola (Plate 16).

The correspondent who described the picture at the exhibition was Canaletto's contemporary, the artist Alessandro Marchesini. He acted

as an advisor to the earliest known Italian collector from whom Canaletto was commissioned to paint some view paintings. In 1725, when Stefano Conti, a textile merchant from Lucca, asked Marchesini to advise him about expanding his collection, Marchesini suggested buying works by Canaletto in preference to those of Carlevaris, using the story of the Ambassador's acquisition in order to convince Conti of the wisdom of this choice. Eventually the collector ordered four works from Canaletto, and Marchesini, who acted as agent, tried to convince him that the artist was an awkward man who had to be handled carefully. Such estimations of Canaletto, repeated by other intermediaries, may well have little to do with his character; it probably had a great deal to do with the desire of agents to convince collectors of their need to intervene. Because of this problem it has proved very difficult to find out what Canaletto the man, as opposed to the artist, was really like.

Patrons such as Conti would have been important to Canaletto at the outset of his career, but it was English collectors who came to dominate the market for his view paintings. Canaletto's earliest work for them came to him as a result of his contact with an Irishman called Owen McSwiney (c1684-1754). This colourful character had worked as a backer for theatrical productions in London, but was bankrupted, and so turned his attention to other enterprises on the Continent, including working as a representative for collectors. In March of 1726 he wrote to the Duke of Richmond about a large series of paintings by Bolognese and Venetian artists, including Canaletto, which he had commissioned, probably on the Duke's behalf. They were allegorical memorials to notable Englishmen and were produced as collaborative works. Canaletto contributed backgrounds, in the form of *capricci*, to two of them, and his involvement with the project probably led to his first direct English commission for view paintings.

McSwiney not only introduced Canaletto to an English clientele, but seems also to have encouraged the painter to create works which might particularly appeal to it (see Plate 7). Such small, bright depictions of famous subjects were quite unlike his earlier, perhaps more personal, localized views. They can still be seen in the homes of numerous British aristocrats, but hardly any of Canaletto's paintings are now exhibited in Venice. So why was collecting Canaletto's work particularly monopolized by the English?

The answer would seem to be because of the Grand Tour, and the process of refined souvenir hunting which it entailed. The Grand Tour was considered a vital part of the education and cultivation of wealthy young Englishmen, and involved visiting the great centres of Italian civilization – Rome, Florence and Venice. An essential part of the process was to acquire reminders of your travels which would enrich your London home and country residence. So Canaletto's view paintings were records of what were then epic journeys. Collectors in England had already developed an appreciation of landscape and view painting – they had acquired many Dutch and Roman landscapes of the previous century, and commissioned 'prospects' of their houses from native artists. Canaletto's deft combination of topography and artistry therefore also fitted in with this existing pattern of taste.

There can be little doubt, though, that his work was sought after not just for these motives, but also because it showed a city teeming with life. This is perhaps most obviously the case in his view paintings which record crowded civic festivities (see Plates 12, 13 and 16), and the scenes of everyday activity (see Plate 5). Canaletto peppered his paintings with Venetians – clerics, boatmen, merchants, ladies, beggars, stall holders and dogs, which appear somewhere in almost

Fig. 6 Overleaf
The Bacino di San Marco: looking East c1735. Oil on canvas, 125 x 204 cm. Museum of Fine Arts, Boston, MA

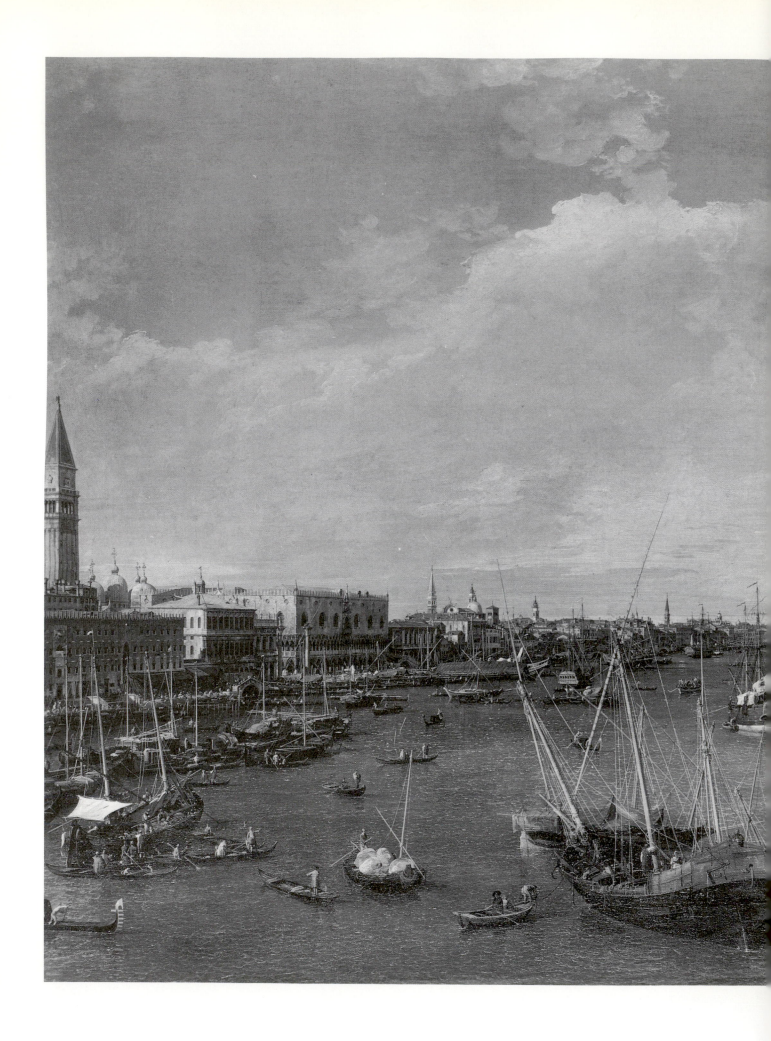

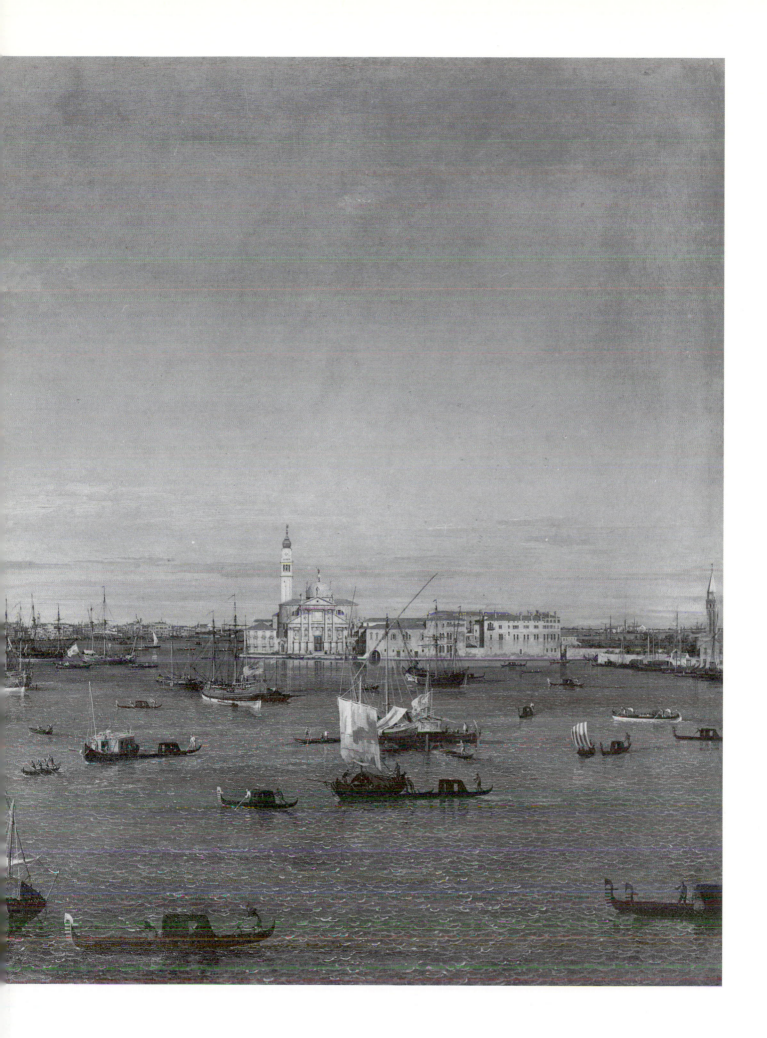

every picture.

The most important promoter of his career and patron was Joseph Smith (*c*1674-1770), an Englishman who lived in Venice. Smith knew McSwiney (the Irishman had acted as an agent for his first wife, an opera singer called Catherine Tofts). Smith was initially employed in the city as a banker, but eventually established himself as an agent who worked on behalf of a number of British collectors of manuscripts, books and works of art, and also served as British Consul to the Republic (1744-1760; 1766). He was a connoisseur who built a notable collection of his own which was housed both in his palace on the Grand Canal and in his villa at Mogliano. This collection eventually included the largest single group of works by Canaletto ever assembled, and was sold en masse to King George III in 1762-3.

Smith's homes were visited by many travellers from England, and so he was ideally placed to build up the British patronage Canaletto had begun to enjoy. He soon became a middleman between the artist and his northern clientele, ensuring that pictures were finished on time and sorting out issues such as how a painting ought to be framed or transported. Their relationship developed from the late 1720s and seems to have been one of mutual benefit. Canaletto could get on with his work while Smith enhanced his own reputation and enriched his collection. Smith first bought from Canaletto a series of views of the Piazza and Piazzetta di San Marco (Plate 6), which may originally have formed part of a decorative scheme in his palace. In them Canaletto unifies what might seem incompatible elements – carefully plotted compositions, and a fluid, at times almost exhilarating use of paint. The result, with the notable exception of 'The Stonemason's Yard', is perhaps the highpoint of the early part of his career.

During the 1730s Smith liaised on Canaletto's behalf with a number of English aristocrats who had by now developed an unquenchable thirst for his work. The most impressive of these sales was to the future 4th Duke of Bedford who eventually acquired a series of 24 pictures (see Plate 14), which are still displayed together in the 'Canaletto Room' at Woburn Abbey. Among other sales from this period which Smith was probably involved with was the acquisition of 11 pictures by the Duke of Leeds.

A number of the pictures Canaletto painted for such patrons at this time are distinguished works, but one particular canvas stands out because it is so ambitious – *The Bacino di San Marco: looking East* (Fig. 6), which is now in the Museum of Fine Arts, Boston. This picture, probably bought by the Earl of Carlisle in Venice in the eighteenth century, is a breathtaking panorama of the entrance to Venice from the sea. The view is more ambitious than any Canaletto had previously studied, and also usefully illustrates how he approached and constructed his paintings. The vista is in fact so broad that it could not actually all be seen at once, and is made from a combination of two views that can only be observed from separate points. This process of linking such elements in a single work was one that was repeated by Canaletto on many occasions.

Before creating such effects in the studio, Canaletto followed a relatively complex procedure. Almost all of his paintings were based ultimately on drawn studies made in the open air. These preparatory sketches generally inspired two types of worked up drawing – those which are highly detailed and have an independent status (see Fig. 27), and those which play an intemediary role between first thoughts and a painting or print (Fig. 9). In total approximately 500 drawings of this type by Canaletto survive.

Canaletto's drawings have remained little known by comparison

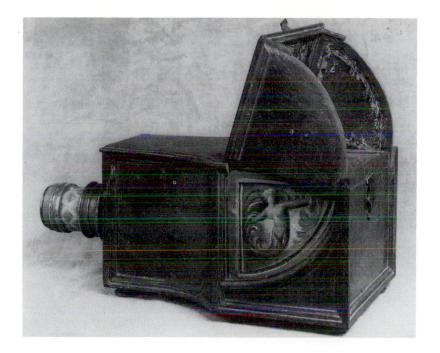

Fig. 7
Camera Obscura
Date unknown. Wood
and brass, lens diameter
3.3 cm. Correr Museum,
Venice

with his paintings. But as well as being informative about his methods, they are an aspect of his work that deserves independent recognition. He usually drew with pen and ink over pencil, and either hatched or employed wash to establish tonal change. As in the best of his paintings, the result is often highly sophisticated, but appears deceptively simple.

His working sketches, particularly those now in the Accademia in Venice, often include notations on colour, or written descriptions of details which acted as an aide memoire (see Fig. 32). They are either of entire compositions, or concentrate on particular buildings and figure groups. The compositions are sometimes re-worked on the canvas with little alteration or combined with other studies from different viewpoints in a single painting, so creating spectacular 'wide angle' or scenographic effects. The impact of such works is further enhanced by the sheer size of the canvases.

Although many of the views Canaletto created could in fact not be seen, they have great conviction and seem unquestioningly to replicate reality. Commentators have suggested that Canaletto used mechanical devices to create them. According to contemporary accounts, he may have developed compositions with the help of a *camera obscura*, or *camera ottica* (Fig. 7). This tool is based upon the same principle as the later pin-hole camera, and consists of a closed, dark box with an aperture in which a lens is placed. Light reflecting from external objects passes through the lens, and is projected, inverted, on a surface such as an opaque glass sheet on the far side of the box, where it can be traced. The projection has to be viewed in the dark (probably with a cloak over your head), so there are practical problems to be overcome. It is likely that if Canaletto did employ such a device, at most it only constituted a starting point from which to work up his drawings and paintings further. The application of this tool may underline the unimaginative way in which Canaletto created his pictures. But this view takes little account of its probable limited use, and misses the point that Canaletto's likely interest in contemporary optical experiments illustrates the breadth of his curiosity. Such preoccupations had been developed by distinguished seventeenth-century Dutch artists, such as Johannes Vermeer (1632-

Fig. 9
Padua: the Prato della
Valle with Santa
Giustina and the
Church of the
Misericordia
*c*1740. Pen and ink on
two sheets of paper,
27.1 x 74.3 cm.
Royal Collection

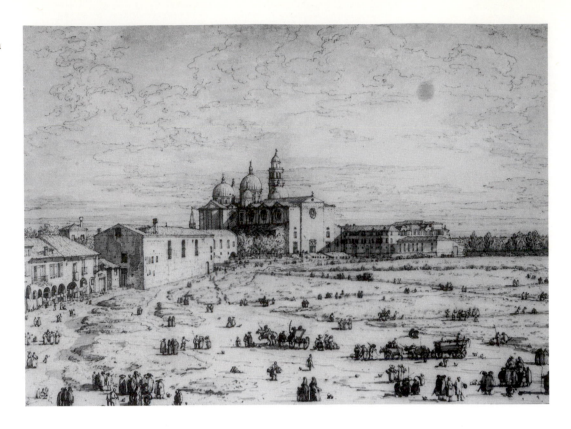

Fig. 8
Title Page to the
second edition of the
*Prospectus Magni
Canalis Venetiarum*

75), one of whose paintings Canaletto could admire in Joseph Smith's collection (*The Music Lesson*, now Royal Collection).

Compositions established on paper, either based on observation or the use of the *camera ottica*, or both, were usually reworked by the artist on a canvas support. Canaletto is known to have painted on copper (see Plate 7), but he generally favoured canvas; it was more practical for large works which were to be transported. Before working on the canvas the artist would have it coated with glue-size, and prepared with a 'ground', a lower layer of paint which would provide a smooth surface on which to work. The hue and tone of the ground effected the overall appearance of the finished picture, and it seems that Canaletto used different grounds during his career. Works examined by conservators and scientists reveal that the grounds in his earlier paintings were generally darker than those used on later pictures, and are variously tinted with creams, ochres and pinks.

Once the ground had been applied the composition could be built up. First large areas of colour were blocked in, for example in the sky, and then the outlines of buildings were established, often using rules and compasses. The definition of details and textures would follow, with chimney pots often being painted over the sky and figures on top of the architecture. Some details of the texture of the buildings would be scored into the wet paint. The paint was made of both man-made and natural pigments, mixed with oil, and often applied from a fairly heavily loaded brush. Canaletto's colours are rich, clear and seem to sing out from the canvas, with each crinoline or flagstaff being given its own precisely established chromatic value. This separation of different hues in combination with the crisp linear precision of the outlines of the buildings gives the pictures their resonance and clarity.

Such definition meant that Canaletto's paintings were ideally suited as the basis for prints. Joseph Smith was aware of this and organized the publication of engravings after works by Canaletto in his collection, in order to spread further both the artist's and his own reputation. In 1735 14 plates by Antonio Visentini of Smith's

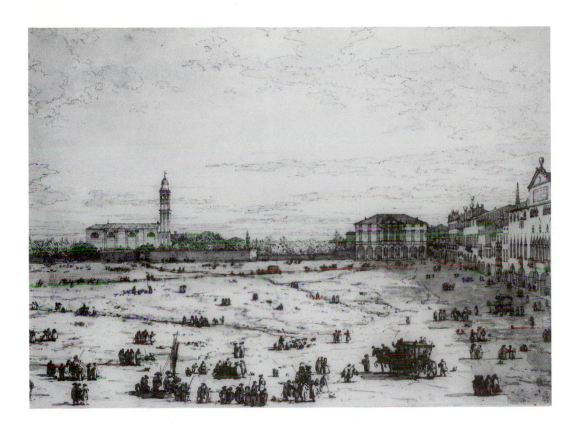

Canalettos were published. They clearly proved successful, because the engravings were reissued in 1742, along with a further 24 prints (Fig. 8).

The extent of the demands being made on the artist in the 1730s and the sheer quantity of work from this period would seem to suggest that Canaletto increasingly did not work alone, but employed studio assistants. Quite how much they contributed to his output has not yet been established with any certainty. Canaletto's father may well have been employed in this capacity, and certainly in the second half of the decade his nephew Bernardo Bellotto (1720-80) trained in his studio. Bellotto initially worked as an assistant before establishing his independence as a painter, printmaker and draughtsman. He is renowned for his view paintings of Dresden, Vienna, Munich and Warsaw.

At the beginning of the next decade Canaletto's fortunes changed quite dramatically because of a series of unforeseen developments. In 1741 the War of Austrian Succession broke out and consequently far fewer foreign visitors could reach Venice; this meant that the artist's principal source of patronage began to dry up. In addition, perhaps for the first time, he experienced some serious competition; in the same year Michele Marieschi (1710-44) published an attractive album of views of Venice. In response Canaletto decided to turn his attention to other subjects, beyond Venice, which would have a wider appeal, and to experiment by working in different media. The decision to embark on this course may also have been prompted simply by a need to find new challenges – Canaletto could never exhaust the pictorial possibilities of Venice, but had come to know its appearance better than most.

Canaletto had probably already made some sketching expeditions outside of the city prior to the early 1740s (see Plate 20). Now he made another important journey along the Brenta canal with Bellotto towards Padua, and executed a number of drawings that were to form the basis of etchings and paintings (see Fig. 9). The stimulus of new

Fig. 10 Below
Title Plate for
Canaletto's Etchings
After 1744. Etching,
29.1 x 42.2 cm.

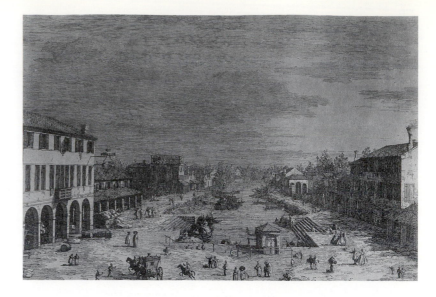

surroundings seems to have had a very positive effect, because these works, although perhaps his least known, can in some cases be counted as the most innovative and attractive. The etchings in particular are noteworthy. He executed in total 34 plates, probably between about 1735 and 1746, and published 31 of them together (Fig. 10). The inscription on their frontispiece reads in translation: 'Views / some representing actual sites, others imaginary / by / Antonio Canal / and by him etched and set in perspective / humbly dedicated / to the most illustrious / Joseph Smith / Consul of his Brittanic Majesty to the Most Serene / Republic of Venice / as a sign of esteem and homage'. Smith became Consul in 1744 and therefore their issue must post-date that year.

The views of 'actual sites' included depictions of Dolo, Mestre, Padua, Venice and the lagoon – in fact almost the entire range of subjects Canaletto explored on canvas. The artist proved himself as adept at capturing the nuances of atmosphere, texture and visual anecdote in this graphic form (Figs. 11 and 12), as in his more prolific paintings. But exactly how he learnt the art of etching is not clear – he certainly would have had contact with the printmakers employed by Smith to reproduce his own work, but may well have been essentially self-taught.

In 1742 Canaletto made his second move away from exclusively

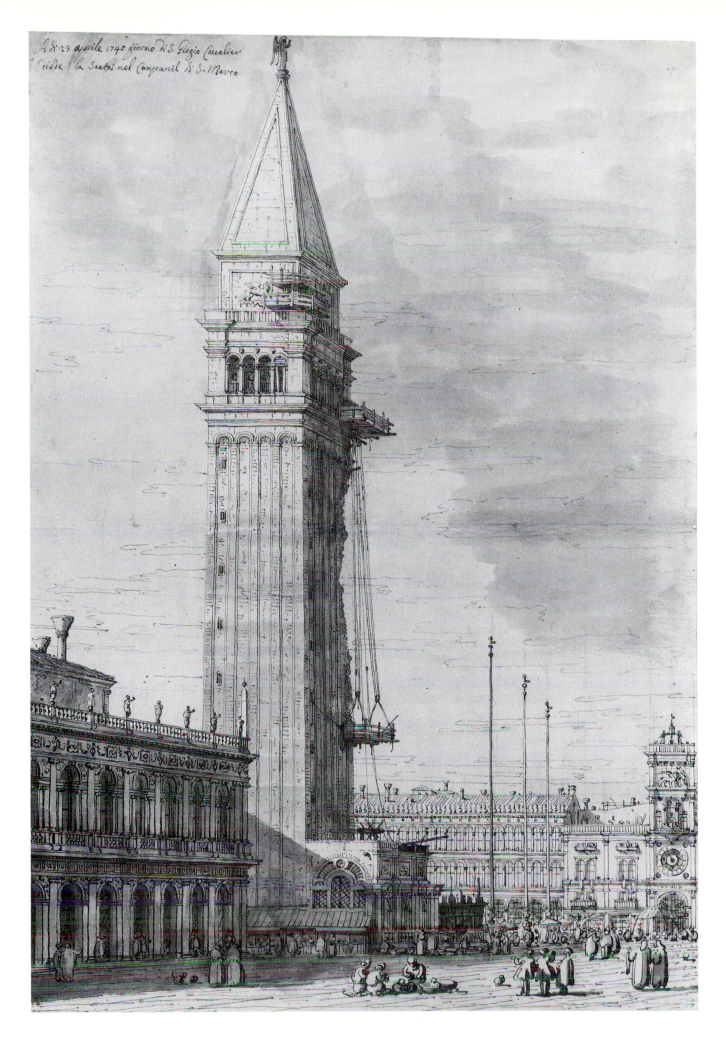

A di 23 aprile 1745 giorno di S. Giorgio Cavalier
erede la Saeta nel Campanil di S. Marco

Venetian subject matter when he painted a series of five large pictures for Smith of ancient Roman ruins (see Plate 22). There has been some debate as to whether they were based on sketches Canaletto made in 1719, or the fruits of a later trip to Rome; it may in fact be the case that neither explanation is satisfactory and that he drew on other sources, such as sketches made by Bellotto (who was in Rome 1740-1), and prints in Smith's collection to which he would have had access. Smith seems to have been dominating almost all of Canaletto's time – he next commissioned the artist to paint a series of 13 'overdoors', nine of which are still in the Royal Collection, which were probably intended for Smith's villa at Mogliano. As their name suggests these works were intended to be set above doorways. A considerable number of Canaletto's paintings were conceived as pairs or larger sets, and were intended to be hung symmetrically in an interior as part of a decorative arrangement. Smith's 'overdoors' were architectural *capricci*, which explore in particular the contemporary taste for Palladian subjects (Fig. 25).

It may have been because of his reliance on this one source of patronage that Canaletto decided over the next year or so actively to seek work elsewhere. In view of the fact that the majority of his patrons were English, it was perhaps predictable, and certainly wise from a commercial point of view, that he should eventually consider travelling to London.

On 23 April 1745 the artist signed and dated a drawing of the Campanile of San Marco which had just been damaged by lightning (Fig. 13); this is the last reference to his presence in Venice. He arrived in London at the end of May 1746, according to the engraver and chronicler George Vertue, who described him as ' . . . the Famous Painter of Views Cannalletti'. Vertue went on to say that Canaletto would no doubt give satisfaction with the works he was to produce in England, and later called him 'a sober man turnd [*sic*] of 50' who 'had done at Venice many, nay multitudes of paintings for English Noble and Gentlemen and great numbers bought by dealers'.

According to Vertue, Canaletto had been persuaded to travel by the Venetian artist Jacopo Amigoni (1682-1752). Whether Amigoni, who had worked in England, did in fact persuade the painter to make the journey is not clear. In doing so, however, he was following a trend already set by other Venetian artists; earlier Marco Ricci, Giovanni Antonio Pellegrini (1675-1741) and Sebastiano Ricci (1659-1734) had also sought employment in London.

Canaletto painted in England intermittently up until 1755, and clearly found his new surroundings attractive. His earliest works of the period are of the Thames and the recently completed Westminster Bridge (Plates 28 and 29). This expanse of water thronged with boats in the centre of a great city was not that far removed thematically from Venetian scenes. Some ways in which Canaletto depicted the Thames are very similar to his treatment of such a view in Venice, most incongruously in the case of the climate. Canaletto's London is generally a city of brilliant blue skies unfamiliar to its population. This deception does, however, have its benefits, because the quality of light in his works brings into focus every architectural detail, so providing a vivid record of the city's appearance.

A number of the compositional and thematic innovations Canaletto tested in London (see Plate 29) stimulated many English artists to look afresh at their surroundings, for example artists such as Samuel Scott (?1702-1772), Paul Sandby (1725/6-1809) and William Marlow (1740-1813).

On a few occasions Canaletto chose views which were soon to

change because of new building developments (see Plates 30 and 33). This desire to make records for posterity of an older order which should be revered was perhaps implicit in his Italian view paintings, which in many instances seem to concentrate on the glories of Renaissance and Baroque architecture. It has been suggested, however, that Canaletto's London clientele particularly admired his ability to depict a city undergoing change, which was on its way to becoming a great maritime capital, like Venice in an earlier age.

Canaletto's initial association with important patrons in London was secured through his loyal agents Smith and McSwiney. Smith gained an introduction for him to the Duke of Richmond, and some of the works Canaletto later painted for this patron (Plates 30 and 31) are widely considered his greatest achievement while in England. They provide a window on to the London of George II which no historian could achieve, but they are far from being simply of documentary interest, as they also succeed as enchanting works of art. As in the artist's Venetian works it is the ebb and flow of people which enliven these unique panoramas. The figures in the foreground are carefully placed as spatial markers, and, as elsewhere in Canaletto's pictures, the colours of their clothes are used as compositional devices, either to counterbalance other features, or to draw attention in a particular direction. They are fluidly but precisely defined, and contrast with the figures the artist placed in crowd scenes which are depicted more schematically, often with tiny dabs of contrasting colour.

Later Canaletto painted subjects outside London – for example, the country homes of the Duke of Beaufort, the Earl of Warwick and the Duke of Northumberland. In many of these works he seems particularly to have been intrigued by the bold forms of the buildings, which would have contrasted with the more delicate architectural detailing he was accustomed to viewing in the Veneto. This is certainly the case with his views of Warwick Castle (Plates 32 and 36), which he depicted on more occasions than any other English building.

Although Canaletto was able to secure such prestigious work, it appears he still felt the need to promote his achievements publicly. He arranged this by advertising, in a newspaper, the exhibition in his lodgings in London of a new painting of St James's Park (probably Plate 33). It has been plausibly suggested that he may have considered this action necessary to smother rumours that he was not in fact the genuine Canaletto – a bizarre notion which was circulating at the time, according to Vertue's notebooks. The idea was perhaps encouraged by the existence of a number of imitators, and the fact that Bellotto also used the name Canaletto.

Canaletto returned briefly to Venice in 1751 (and may also have travelled home again in 1753), but then seems to have remained in England up until 1755. Among the important works from this period are a series of *capricci* for the Lovelace family (see Plate 42) and a group of six pictures which were painted for Thomas Hollis (see Plate 39). Hollis was a collector with republican sympathies who had travelled across Europe and become acquainted with Smith. Most of the works he ordered from Canaletto were based on exisiting pictures, but Hollis also acquired from him one celebrated painting of considerable originality – *Old Walton Bridge* (Plate 40). In this delightful work Canaletto subtly included a portrait of his patron in the landscape, and finally, before his return to Italy, depicted a recognizably English squall.

Canaletto's last years in Venice from 1756 onwards are not as artistically noteworthy. Many of his later pictures were based on

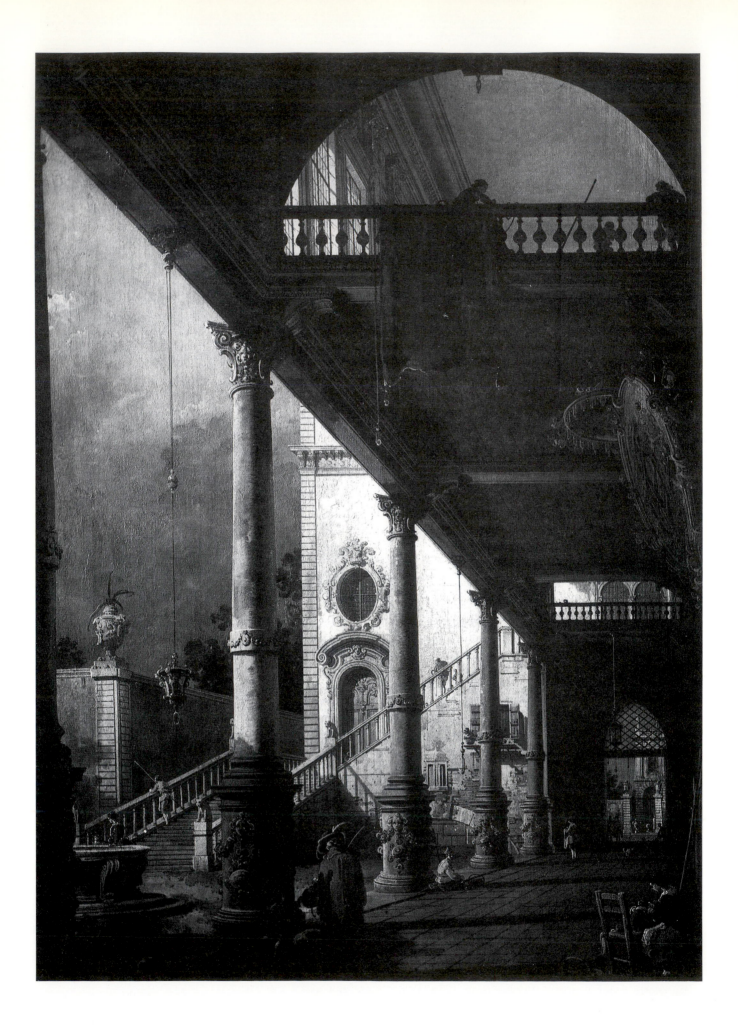

compositional and technical formulae worked out some years before. There are, however, a few exceptions to this trend. These include four works he painted for the German patron Sigmund Streit (see Plate 44), and the small pair of views of the Piazza San Marco in the National Gallery, London (Plates 46 and 47). These pictures show a willingness to look at familiar subjects from new perspectives, and suggest that when Canaletto did so he could still summon up the the wit, observation and ingenuity which distinguishes his work from that of assistants and copyists.

An intriguing record of Canaletto working in the open air at this time has been handed down to us. According to a much later account, John Hinchcliffe, who was to become Bishop of Peterborough, when in Venice in 1760 saw 'a little man' sketching the Campanile of San Marco. He interrupted the artist, who turned out to be Canaletto, and the two struck up a friendship. Canaletto then gave Hinchcliffe the drawing, and he bought the related painting. Hinchcliffe's companion in the city was a man called John Crewe who also bought a spectacular view of London from Canaletto (see Fig. 28). It is still possible to get an impression of what Canaletto might have looked like when seen working outside, because he seems to have depicted himself as such in at least two pictures (see Plates 22 and 40).

In 1763 Canaletto was finally elected to the Venetian Academy of Fine Arts, the institution which essentially dictated establishment taste in the city. His admission to the Academy had been rejected on a couple of previous occasions, probably because view painting was not highly esteemed by a body which prized the work of figurative and history painters above all else. The artist's reception piece, *Capriccio: A Colonnade Opening on to the Courtyard of a Palace* (Fig. 14), was completed almost two years later. It is a complicated architectural *capriccio* which as an exercise in creating a sophisticated perspectival scheme certainly displays Canaletto's ingenuity. This effect may be intentional – such complexity would appeal to the intellectual pretensions of the Academy, so heightening the status of his work. Curiously the picture also seems to hark back to the artist's initial theatrical training. This is because in some ways it works like a *scena per angolo*, or stage set, which has a recession set at an angle to the audience, so giving a convincing impression of space.

The very last of Canaletto's dated works is a drawing of the following year (Plate 48), which is defiantly inscribed, and illustrates no lessening of his skills in old age. Canaletto died of a fever aged 71, on 10 April 1768. He was buried in the church of San Lio, where he had been baptized. He had not made a will, and so an inventory of his posessions was drawn up; they included a number of paintings, some money and one investment in property. These relatively humble assets are perhaps surprising in view of his apparently successful career, and can be contrasted with the rich legacy of his work, which inspired numerous later travellers, collectors and view painters.

The critical history of Canaletto's work can be plotted from long before his death. Most of his contemporaries who recorded their views on his painting were appreciative of his skills. The artist Marieschi, who had acted as an early agent for Canaletto, wrote in 1725 of his pictures that 'we can see the sun shine within them', and the French scholar Charles de Brosse in 1739 called his manner 'gay, lively, clear and wonderfully detailed'. These comments are certainly accurate, but cannot be described as penetrating analysis. The biographer Antonio Zanetti certainly provided it, however, in his *Della Pittura Veneziana* (1771):

Fig.14 Opposite
Capriccio: A
Colonnade Opening
on to the Courtyard of
a Palace
1765. Oil on canvas,
131 x 93 cm.
Accademia, Venice

Canaletto united pictorial liberty and nature with such economy that his true works are obvious to those who have no more than common sense to judge with; while the connoisseur all the more finds great art in them in the choice of sites, the distribution of figures, the handling of light and shade; and in addition, a lucidity and piquant facility of colour and of brushwork, the effects of a calm mind and happy genius.

This is not hollow eloquence, but succeeds in pointing to the central combination of artifice and observation ('pictorial liberty and nature') which raises Canaletto's paintings above those of the topographer. Zanetti also isolates the way in which they work on different levels – simply to please, and also to provide delight in their ingenuity for those knowledgeable about the artist's techniques and subjects.

It was not until the 1830s that a few critical voices began to oppose such views; they are sometimes quite difficult to understand from a modern viewpoint, particularly when they are directed towards works such as 'The Stonemason's Yard'. This picture was given to the National Gallery in London by one of its founding Trustees, Sir George Beaumont. It was catalogued in 1832 by William Young Ottley, who expressed reservations about its merits: he wrote that ' … the effect of it, as a whole, is not very agreeable; though every part is painted with the artist's accustomed boldness and decision of pencil.'

Such judgements, although surprising, pale beside the highly emotive comments made slightly later by the critic John Ruskin. In his *Modern Painters*, Ruskin was unstinting in his damnation of Canaletto, whom he described as 'professing the most servile and

mindless imitation', and as 'a little and a bad painter'. These memorable descriptions, which came from a man who perhaps saw himself as the best interpreter of Venice (and had probably seen very few of Canaletto's pictures), were not taken up elsewhere. On one point they are, however, quite illuminating. Ruskin says that in his view Canaletto 'professes nothing but coloured daguerrotypism...' The daguerrotype, named after its inventor Louis-Jacques-Mandé Daguerre (1789-1851), was one of the earliest forms of photographic reproduction, which at this time was a relatively recent technical innovation. Comparing Canaletto's pictures to photographs subsequently became a theme often taken up by commentators on his work – the association could either be used to illustrate his skills as an observer and recorder of reality, or, depending on your point of view, to underline his lack of imagination. Such discussions parallel the debate over his use of the *camera obscura*.

Ruskin's favourite painter, J M W Turner (1775-1851), in contrast to his sponsor saw in Canaletto's work much to be admired. He publicly expressed his appreciation in a painted tribute to him, called *The Bridge of Sighs, Doge's Palace and Customs House, Venice: Canaletto Painting* (Tate Gallery, London), exhibited in 1833. Canaletto does seem to have become a painters' painter, rather than a critics' hero. A long line of British artists before Turner were inspired by his work in England to extend their range of subjects to untested parts of the urban scene. Both the French painter Édouard Manet (1832-83) and James McNeill Whistler (1834-1903) expressed their admiration for him. Whistler was described on one occasion, after having arrived at the National Gallery in London, as going 'at once to almost *smell* the Canalettos'.

In the twentieth century Canaletto's reputation has developed principally in two directions. His popular appeal has grown and scholars now deem him a figure worthy of consideration. Because of the growth of the literature on Canaletto a reliable overview of his career has emerged, which explains the relationship between its different aspects and proposes a new chronology. The process of developing it has been a slow one though because of the survival of surprisingly little documentation, in view of Canaletto's fame, and the rarity of signatures or dates on his works.

It is not easy to explain why his paintings have become so widely admired. The explanation may lie partly in the fact that, because of their clarity, they are ideally suited to reproduction, and so readily available, unlike those of so many other old masters. In addition, although they are often intrinsically complex, they have an immediate attraction as bright and legible images which carry no earnest message, and rarely presuppose knowledge. But finally perhaps it is his subject matter which appeals most. City life, as the Impressionists showed, is essentially a modern theme, and in his hands it became a reassuring and optimistic one (Fig. 15).

In spite of all this it has to be admitted that Canaletto's pictures still sometimes require defenders. His reputation has suffered because of their uneven quality, often repetitious nature, and numerous derivatives, which have watered down their impact. But when Canaletto lived up to Zanetti's description, of being a 'calm mind and happy genius', as for example in the case of 'The Stonemason's Yard', or some of the later English view paintings, he is, arguably, one of the most distinguished painters of the eighteenth century.

Outline Biography

1697 17 or 18 October, the birth in Venice of Giovanni Antonio Canal, who became known as Canaletto. He was baptized in the church of San Lio.

1719 Canaletto and his father, Bernardo, travel to Rome to design scenery for operas by Scarlatti.

1720 The artist's name is first recorded in the register of the Venetian painters' guild.

1725 Commissioned to paint four works for the merchant Stefano Conti.

1726 First documentary reference to a series of paintings of imaginary tombs commissioned by Owen McSwiney, to which Canaletto contributed earlier in the 1720s.

1730 Joseph Smith, Canaletto's most important patron and agent, orders paintings from him for Samuel Hill (Plates 10 and 11).

1735 Publication of a set of engravings by Antonio Visentini after the Canalettos in Smith's collection, called the *Prospectus Magni Canalis Venetiarum*, which includes the only reliable portrait of the artist (Fig. 1).

1741 The outbreak of the War of Austrian Succession.

1740-1 Canaletto travels along the Brenta Canal towards Padua, and makes a number of drawings, some of which form the basis of paintings and etchings.

1742 Canaletto signs five pictures of Roman subjects (see Plate 22) commissioned by Smith; second edition of the *Prospectus Magni Canalis Venetiarum* published.

1745 Canaletto inscribes a drawing which shows the Campanile of San Marco after it had been struck by lightning (Fig. 13).

1746 George Vertue records that Canaletto arrived in London in the spring; Canaletto worked in England intermittently until 1755.

1747 Painted two important paintings of Whitehall and the Thames for the Duke of Richmond (Plates 30 and 31).

1748 Canaletto starts painting views of Warwick Castle (Plate 32).

1749 Canaletto advertises a painting of St James's Park (probably Plate 33) in a London newspaper.

1750 Canaletto briefly returns to Venice, and makes an investment in some property.

1754 Canaletto, working again in London, inscribes paintings for Thomas Hollis (Plates 39 and 40).

1755 The artist returns to Venice permanently.

1760 He is seen by the Englishmen Hinchcliffe and Crewe sketching in the Piazza San Marco.

1762-3 Joseph Smith sells much of his collection, including numerous works by Canaletto, to King George III.

1763 Canaletto is elected Prior of the Venetian Academy of Fine Art.

1765 Delivery of his Reception Piece for the Academy.

1766 The artist inscribes his last dated work, a drawing of the interior of San Marco (Plate 48).

1768 19 April, the death of Canaletto. He was buried in the church of San Lio, Venice, where he had been baptized.

Select Bibliography

K T Parker, *The Drawings of Antonio Canaletto in the Collection of His Majesty The King at Windsor Castle*, London, 1948

M Levey, *The Later Italian Pictures in the Collection of Her Majesty The Queen*, London, 1964

D Bindman and L Puppi, *The Complete Paintings of Canaletto*, London, 1970

M Levey, *National Gallery Catalogues: The Seventeenth- and Eighteenth-century Italian Schools*, London, 1971

R Bromberg, *Canaletto's Etchings*, London, 1974

J G Links, *Canaletto and his Patrons*, London, 1977

F Haskell, *Patrons and Painters*, 2nd edn, London, 1980

M Levey, *Painting in Eighteenth-century Venice*, 2nd edn, Oxford, 1980

O Millar, *Canaletto: Paintings & Drawings*, exhibition catalogue, The Queen's Gallery, Buckingham Palace, London, 1980-1

A Corbuz, *Canaletto una Venezia immaginaria*, Milan, 1985

K Baetjer and J G Links, *Canaletto*, exhibition catalogue, Metropolitan Museum of Art, New York, 1989

W G Constable, revised and amplified by J G Links, *Canaletto, Giovanni Antonio Canal*, 3rd edn, London, 1989

F Vivian, *The Consul Smith Collection*, exhibition catalogue, Frankfurt, 1989-90

R Wittkower, *Art and Architecture in Italy 1600-1750*, 3rd edn, London, 1992

J Farrington and M Liversidge (eds.), *Canaletto & England*, exhibition catalogue, Birmingham Museums and Art Gallery, 1993

A King's Purchase, King George III and the Collection of Consul Smith, exhibition catalogue, The Queen's Gallery, Buckingham Palace, London, 1993

J G Links, *Canaletto*, 2nd edn, London, 1994

List of Illustrations

Colour Plates

22 Rome: the Arch of Constantine
1742. Oil on canvas, 181.5 x 103 cm.
Royal Collection

23 Rome: Ruins of the Forum, looking
towards the Capitol
1742. Oil on canvas, 188 x 104 cm. Royal Collection

24 Capriccio: the Ponte della Pescaria and
Buildings on the Quay
1742-4. Oil on canvas, 84.5 x 129.5 cm.
Royal Collection

25 Capriccio: the Horses of San Marco
in the Piazzetta
1743. Oil on canvas, 108 x 129.5 cm.
Royal Collection

26 Capriccio: the Grand Canal, with an
Imaginary Rialto Bridge and Other
Buildings
1740s. Oil on canvas, 60 x 82 cm.
National Gallery, Parma

27 Entrance to the Grand Canal: looking East
1744. Oil on canvas, 127 x 203 cm. Royal Collection

28 London: Westminster Bridge from the
North on Lord Mayor's Day
1746. Oil on canvas, 96 x 137.5 cm.
Yale Center for British Art, New Haven, CT

29 London: seen through an Arch of
Westminster Bridge
1746-7. Oil on canvas, 57 x 95 cm.
Duke of Northumberland

30 London: Whitehall and the Privy Garden
from Richmond House
1747. Oil on canvas, 106.7 x 116.8 cm.
Trustees of Goodwood House, West Sussex

31 London: the Thames and the City of
London from Richmond House
1747. Oil on canvas, 105 x 117.5 cm.
Trustees of Goodwood House, West Sussex

32 Warwick Castle: the South Front
1748. Oil on canvas, 75 x 120.5 cm.
Thyssen-Bornemisza Collection, Madrid

33 London: the Old Horse Guards from
St James's Park
1749. Oil on canvas, 117 x 236 cm.
Tate Gallery, London (Sir Andrew Lloyd Webber
Art Foundation)

34 London: the Old Horse Guards and
Banqueting Hall, from St James's Park
1749. Oil on canvas, 45.5 x 76 cm.
Private collection

35 London: Westminster Abbey, with a
Procession of Knights of the Bath
1749. Oil on canvas, 99 x 101.5 cm.
Dean and Chapter of Westminster Abbey, London

36 Warwick Castle: the East Front
1752. Oil on canvas, 73 x 122 cm.
City Museum and Art Gallery, Birmingham

37 London: Northumberland House
1752. Oil on canvas, 84 x 137 cm.
Duke of Northumberland

38 London: Greenwich Hospital from the
North Bank of the Thames
c1753. Oil on canvas, 66 x 112.5 cm.
National Maritime Museum, London

39 London: Ranelagh, Interior of the Rotunda
1754. Oil on canvas, 46 x 75.5 cm.
National Gallery, London

40 Old Walton Bridge
1754. Oil on canvas, 48.8 x 76.7 cm.
Dulwich Picture Gallery, London

41 Eton College Chapel
c1754. Oil on canvas, 61.5 x 107.5 cm.
National Gallery, London

42 Capriccio: River Landscape with a
Column, a Ruined Roman Arch, and
Reminiscences of England
c1754. Oil on canvas, 132 x 104 cm.
National Gallery of Art, Washington DC

43 San Marco: the Interior
c1755. Oil on canvas, 36.5 x 33.5 cm.
Royal Collection

44 Grand Canal: looking South-East from the
Campo Santa Sophia to the Rialto Bridge
c1756. Oil on canvas, 119 x 185 cm.
Gemäldegalerie, Berlin

45 Piazza San Marco: looking South-West
1750s. Oil on canvas, 67.3 x 102 cm.
Wadsworth Atheneum, Hartford, CT

46 Piazza San Marco: looking East from the
North-West Corner
c1760. Oil on canvas, 46.5 x 38 cm.
National Gallery, London

47 Piazza San Marco: looking East from the
South-West Corner
c1760. Oil on canvas, 45 x 35 cm.
National Gallery, London

48 San Marco: the Crossing and North
Transept, with Musicians Singing
1766. Pen and ink with washes, 47 x 36 cm.
Kunsthalle, Hamburg

Text Illustrations

Comparative Figures

16 Piazza San Marco: looking East
Before 1723. Oil on canvas, 142 x 205 cm.
Thyssen-Bornemisza Collection, Madrid

17 Santi Giovanni e Paolo
Leaves from Canaletto's Sketchbook.
Mid 1730s. Pen and ink on paper, each
22.8 x 17 cm. Accademia, Venice

18 Piazzetta San Marco looking towards the
Torre dell' Orologio
Mid 1720s. Pen and brown ink over pencil on
paper, 23.4 x 18 cm. Royal Collection

19 Detail from Plate 8

20 Venice: Riva degli Schiavoni
Early 1730s. Pen and ink over pencil on
paper, 19.6 x 30.9 cm. Royal Collection

21 Venice: The Canale di San Marco with the
Bucintoro at Anchor
Early 1730s. Pen and ink over pencil on
paper, 26.8 x 37.6 cm. Royal Collection

22 The Arsenal: the Water Entrance
Early 1730s. Pen and ink on paper, 27.1 x 37.2 cm.
Royal Collection

23 Detail from Plate 16

24 The Arch of Titus
1742. Oil on canvas, 190 x 104 cm. Royal Collection

25 Capriccio: a Palladian Design for the
Rialto Bridge
1742-4. Oil on canvas, 90 x 130 cm. Royal Collection

26 Capriccio: a Palladian Design for the Rialto
Bridge, with Buildings at Vicenza
1740s. Oil on canvas, 60.5 x 82 cm.
National Gallery, Parma

27 London: Westminster Bridge under Repair;
from the South-West
1749. Pen and ink with wash on paper,
29.3 x 48.4 cm. Royal Collection

28 London: Whitehall and the Privy Garden,
looking North
Probably 1751. Oil on canvas, 118.5 x 273.5 cm.
Duke of Buccleuch and Queensberry, Bowhill

29 London: the Thames and the City
of London from the Terrace of
Richmond House
Probably 1747. Pen and ink with wash on paper,
33.7 x 54 cm. The Earl of Onslow

30 London: the Old Horse Guards and the
Banqueting Hall, Whitehall
1749. Pen and ink on paper, 11.4 x 21.7 cm.
Accademia, Venice

31 Warwick Castle: the East Front from
the Courtyard
1748-9. Oil on canvas, 75 x 122 cm.
City Museum and Art Gallery, Birmingham

32 Old Walton Bridge
1755. Pen and brown ink and grey wash, 29 x
63 cm. Yale Center for British Art, New Haven, CT

33 Campo di Rialto
c1756. Oil on canvas, 119 x 185 cm.
Gemäldegalerie, Berlin

34 Piazza San Marco: looking East from the
South-West Corner
c1760. Pen and ink with wash on paper,
19 x 28.2 cm. Royal Collection

35 San Marco: (an evening service)
c1730. Oil on canvas, 28.6 x 19.7 cm.
Royal Collection

Probably before 1723. Oil on canvas, 140 x 200 cm. Ca' Rezzonico, Venice

Fig. 16
Piazza San Marco:
looking East
Before 1723. Oil on
canvas, 142 x 205 cm.
Thyssen-Bornemisza
Collection, Madrid

This is one of a set of four paintings by Canaletto, usually regarded as his earliest surviving *vedute* (view paintings) of Venice. They may have been executed for a Venetian patron, but are first recorded in the collection of the Princes of Liechtenstein in 1806. It is a work of such extraordinary accomplishment that it is hard to believe it was not preceded by other, now lost, studies by the artist.

Unlike other pictures from the same set (Fig. 16), it shows a part of the city not found on the itinerary of most visitors. This is an area where Venetians live and work, rather than a well-known site. At the left the footway runs along before the church of San Lazzaro dei Mendicanti and the Scuola di San Marco. A wooden bridge spans the canal, while beyond it can be seen the Ponte del Cavallo. The artist has particularly exploited the colourful laundry hung out from the rooftops and windows at the right. There is a heavy, ponderous atmosphere, achieved through the dappled treatment of the silvery light and feathery brushstrokes. This approach, which in part anticipates the work of the Venetian painter Francesco Guardi (1712-93), is characteristic of Canaletto's earliest pictures.

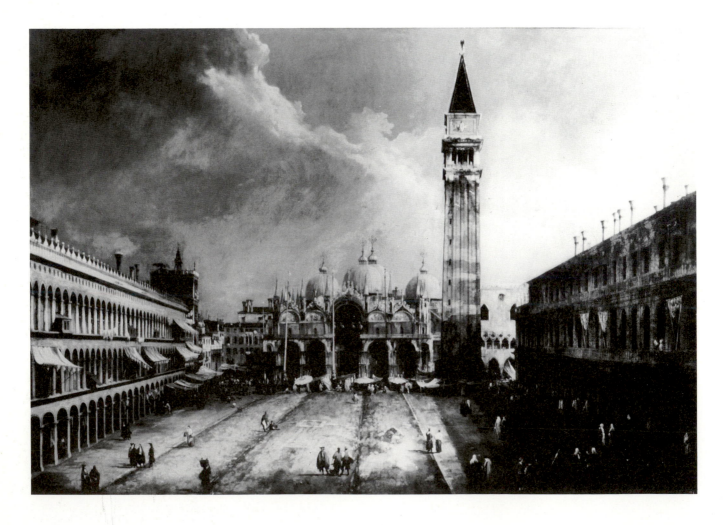

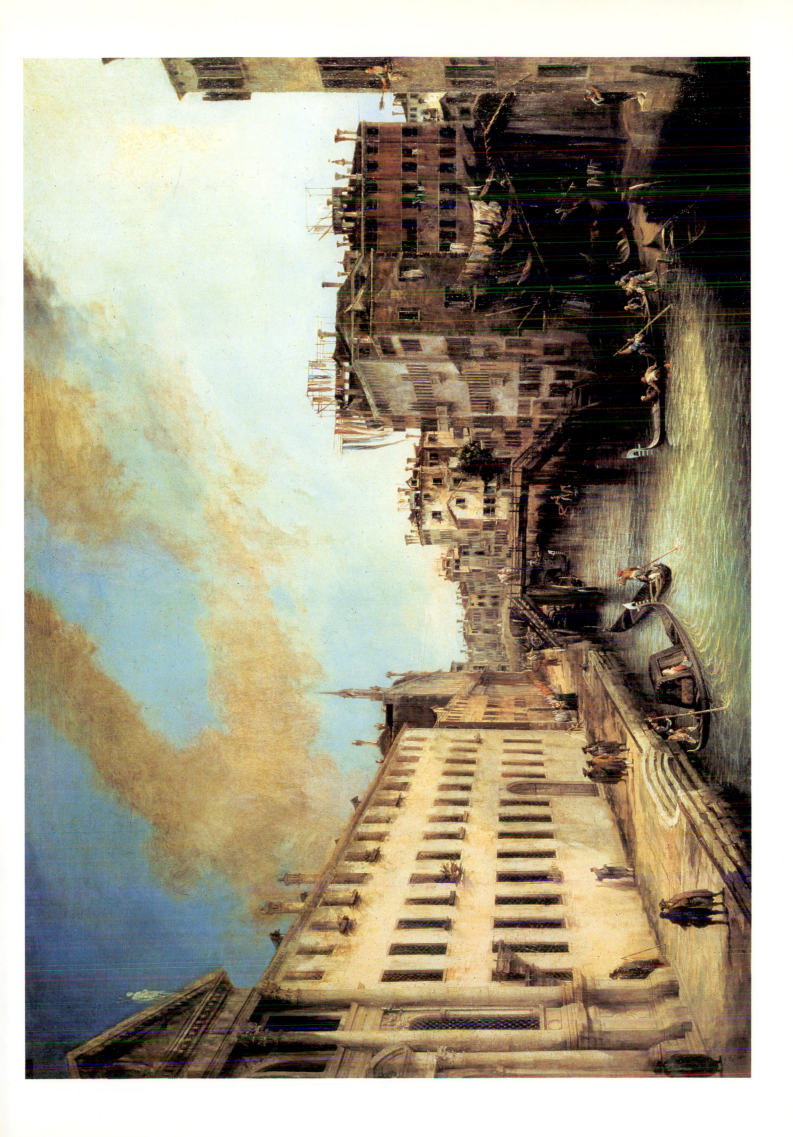

2 # Grand Canal: looking East, from the Campo San Vio

*c*1725. Oil on canvas, 65.5 x 97.5 cm. Gemäldegalerie Alte Meister, Dresden

Canaletto was to return to paint this scene on no less than twelve occasions in the 1720s and 1730s. This is a view from beside the Campo San Vio, looking towards the Bacino San Marco, with the dome of Santa Maria della Salute above the palaces at the right.

Canaletto has included a curious detail: a depiction of a boat on the wall of the building in the right foreground. Whether this was simply a *graffito* or some form of trade sign is not entirely clear. Above it a woman looks down from a small balcony; Canaletto placed similar figures at the edge of a number of his pictures, in order to close off the scene. He also perhaps was trying to convince us that there were in fact vantage points from which the panoramas he shows could be viewed.

This work is from a group of early pictures by Canaletto (including Plate 3), now in Dresden, which were part of the Elector of Saxony's collection during Canaletto's lifetime.

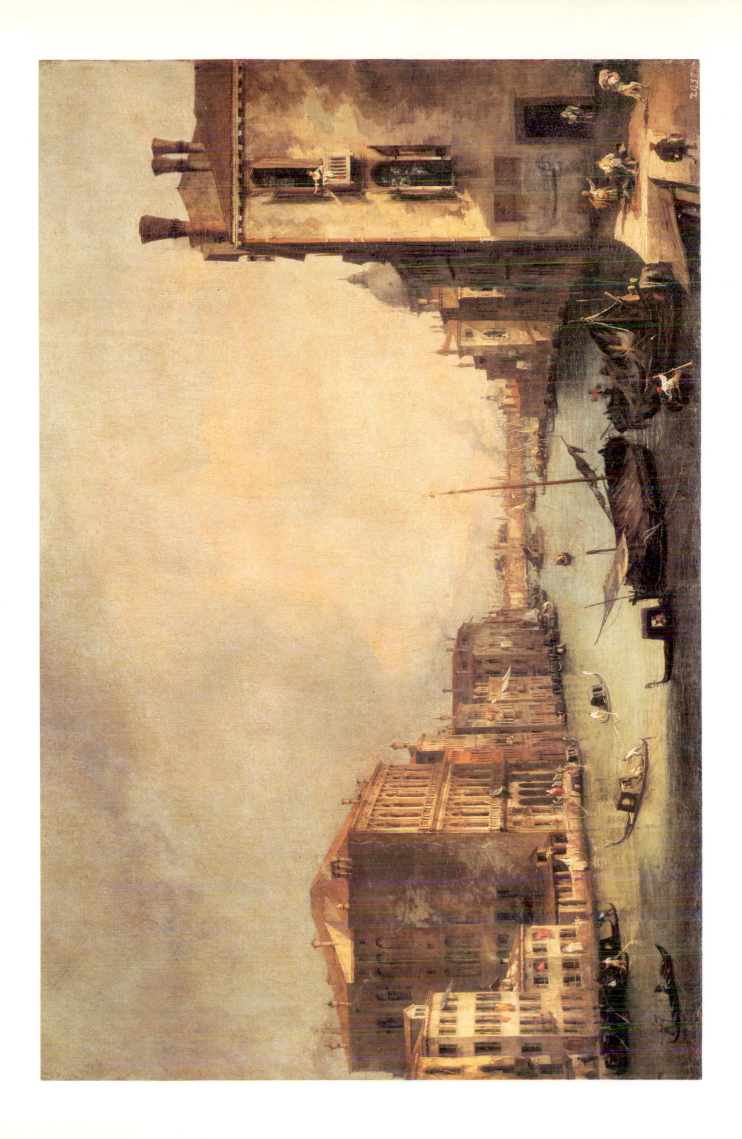

3

Grand Canal: looking North-East from the Palazzo Corner-Spinelli to the Rialto Bridge

c1725. Oil on canvas, 146 x 234 cm. Gemäldegalerie Alte Meister, Dresden

Various features of this picture are arranged like the lighting and props in an operatic production, in order to create a compelling rather than simply descriptive image. These features perhaps refer to Canaletto's early experience in the theatre. The ominous sky provides an element of menace and restlessness rare in his work, and the unlikely grouping of boats in the right foreground seem to have been placed for picturesque, rather than a realistic, effect.

The view of the buildings is, however, based upon a recognizable one. The landing stage at the right is that of the San Angelo *traghetto* (ferry), and beyond it can be seen part of the Palazzo Corner-Spinelli. At the left, with a sailing barge moored before it, is the Palazzo Barbarigo della Terrazza.

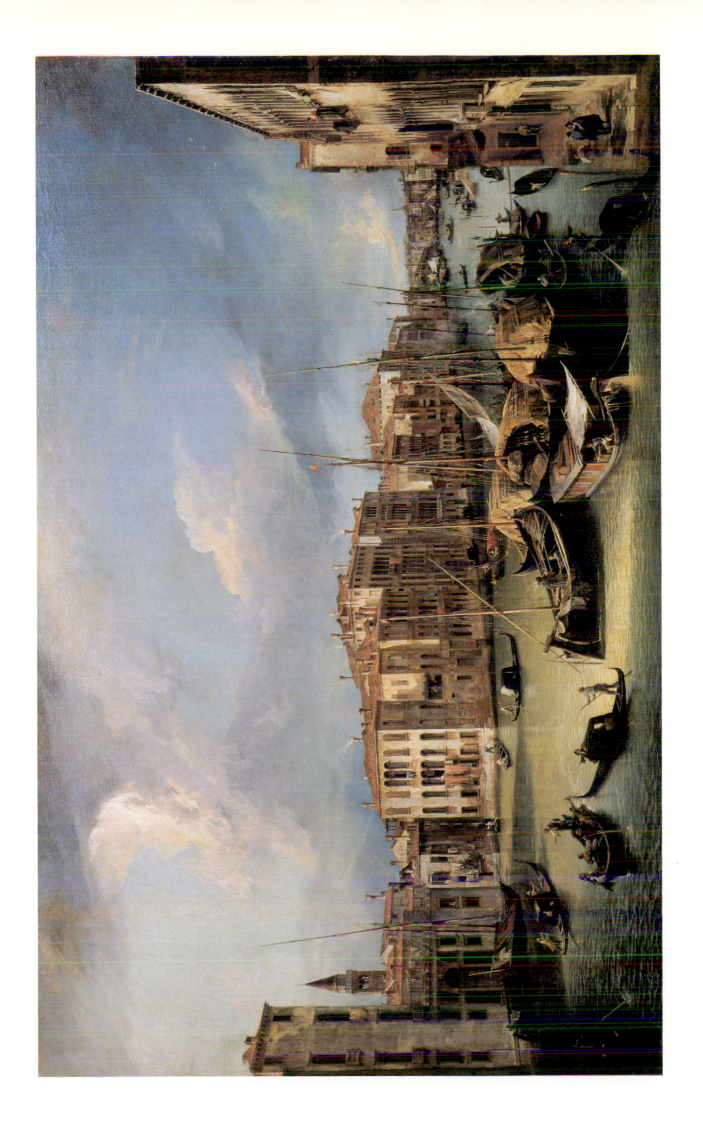

*c*1725. Oil on canvas, 65 x 98 cm. Gemäldegalerie Alte Meister, Dresden

The magnificent Baroque church of Santa Maria della Salute, designed by Baldassare Longhena, dominates the scene at the right. To the left of centre, in the middle distance, can be seen the Doge's Palace, and further over the Campanile of San Marco.

Canaletto was to return to paint this view on a number of occasions, and it is instructive to compare this, his first interpretation of it, with a later treatment (Plate 27). In this picture the agitated brushwork effectively evokes a stormy sky and blustery breeze. By contrast, in the later painting the scene is one of far greater serenity, with no sails billowing in the wind, and all the architectural details clearly described. The comparison illustrates more than simply a shift in style, however; it suggests Canaletto found a challenge in reworking a familiar subject, so creating a quite different experience for the viewer.

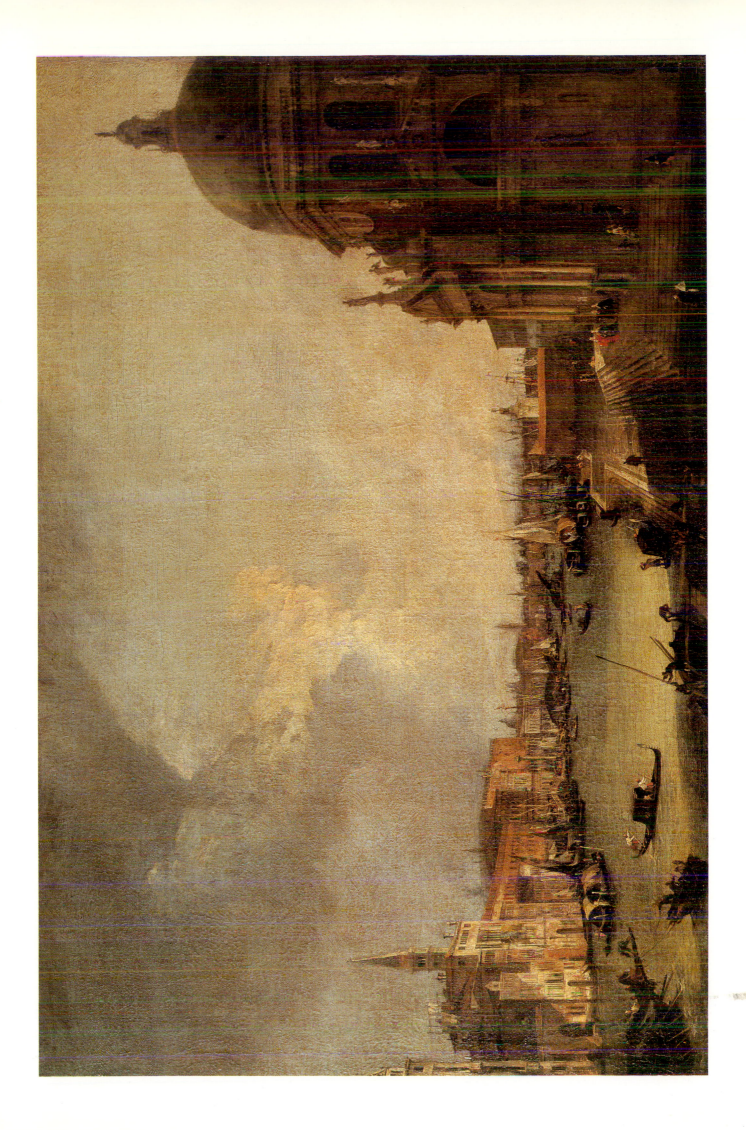

Santi Giovanni e Paolo and the Scuola di San Marco

*c*1725. Oil on canvas, 125 x 165 cm. Gemäldegalerie Alte Meister, Dresden

Santi Giovanni e Paolo, the most important Dominican church in Venice, is depicted at the left, with the equestrian monument to Bartolommeo Colleoni by the Italian sculptor Andrea Verrocchio (*c*1435-88) in front of it. Beside the church and in the centre of the composition is the Scuola Grande di San Marco, the wealthiest of the six major philanthropic confraternities in the city. The square before it is teeming with a variety of figures: beggars, a mother and child, traders, elegant ladies and dogs.

It is probable that this work was acquired by the Ambassador of the Holy Roman Empire to Venice at the annual exhibition of paintings held outside the Scuola di San Rocco, which Canaletto later depicted (Plate 16). Works were displayed at such exhibitions by many leading painters of the time.

Fig. 17
Santi Giovanni e
Paolo
Leaves from Canaletto's
Sketchbook. Mid 1730s.
Pen and ink on paper,
each 22.8 x 17 cm.

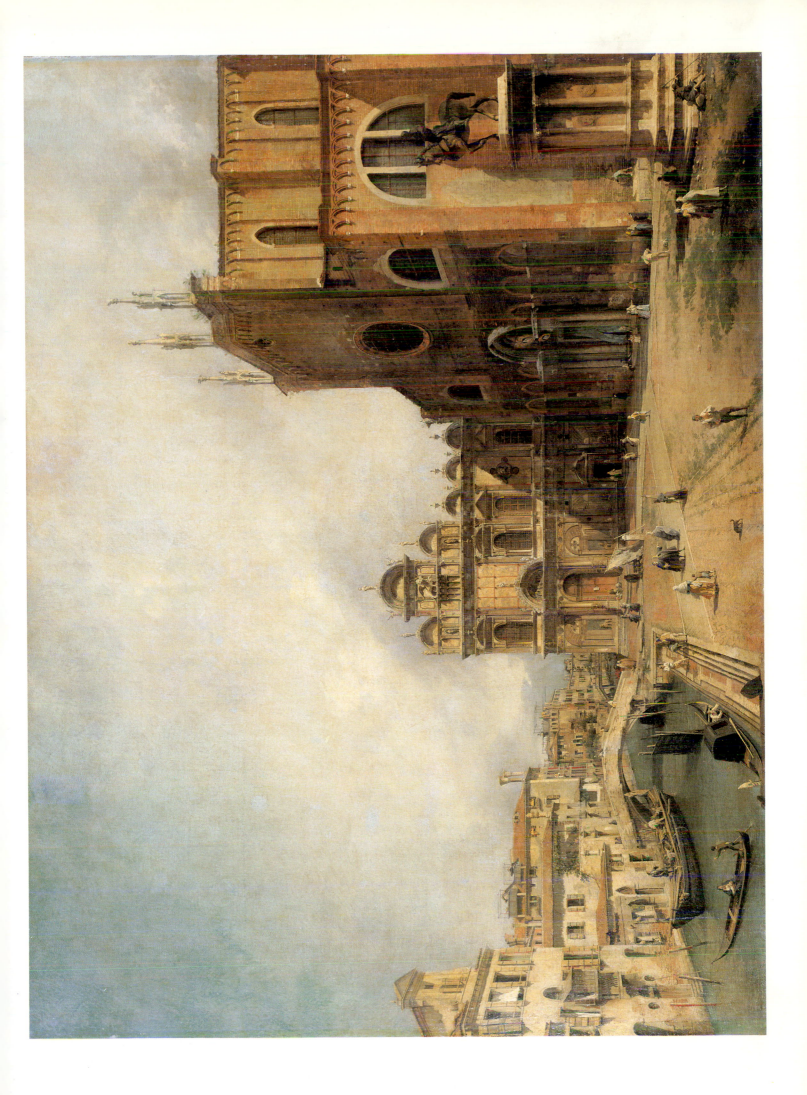

*c*1727. Oil on canvas, 170.2 x 129.5 cm. Royal Collection

Fig. 18
Piazzetta San Marco
looking towards the
Torre dell' Orologio
Mid 1720s. Pen and brown
ink over pencil on paper,
23.4 x 18 cm.
Royal Collection

Canaletto's agent, Joseph Smith, was also his most important patron. Smith acquired a large number of paintings, drawings and prints by the artist, spanning much of Canaletto's career. The earliest of these was a series of six paintings of the Piazza and Piazzetta in Venice, which may originally have been conceived as part of a decorative scheme for a room in Smith's palace on the Grand Canal.

This is a view of the Piazzetta, looking towards the Torre dell' Orologio (clocktower), a subject he was later to return to in a 'close-up' form (Plate 9). The composition is framed by the Biblioteca Marciana and Campanile at the left, and column of San Teodoro and San Marco at the right. The figure wearing a brilliant scarlet robe in the left foreground is a Procurator, and the man in black who follows him may well be a notary.

Canaletto, following much of the scheme established in his preparatory drawing, has deviated from a strict description of the topography. The perspectival recession is artificially severe, and he has taken liberties with the placement of the buildings and flagstaffs. The result is an ingeniously deceptive creation, which immediately draws in the attention of the viewer.

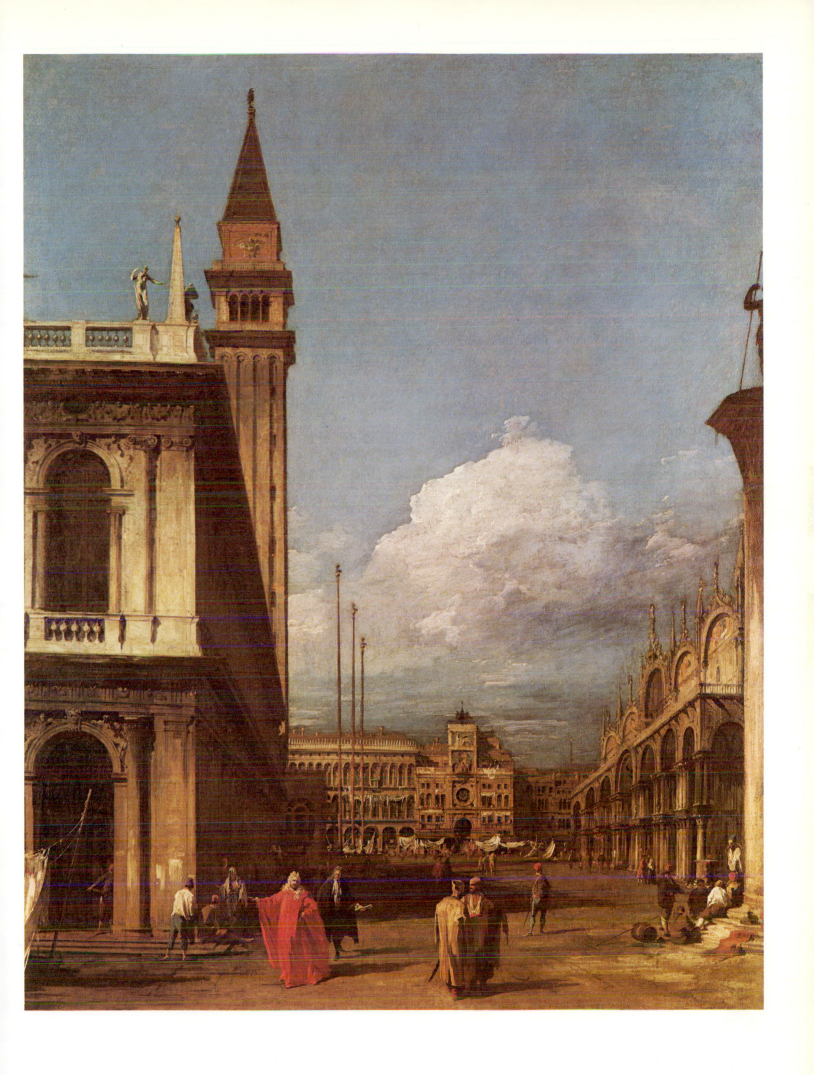

Grand Canal: the Rialto Bridge from the South

*c*1727. Oil on copper, 45.5 x 62.5 cm. Holkham Hall, Norfolk, Viscount Coke

Canaletto generally favoured painting on canvas, but he also executed nine small works with copper supports, of which this is a fine example. Beaten copper sheets provided a very smooth surface upon which to paint, and were usually used by artists concerned with depicting fine details.

The companion picture to this work, also in the Holkham collection, shows the same view as Plate 2. Both paintings are thought to have been bought by the Earl of Leicester, who died in 1759.

The dominant hues and tones are warmer and lighter than in the artist's earlier paintings, and as such mark the direction his work was increasingly to take. The topography is accurate and the site a famous one – a combination particularly favoured by English Grand Tourists.

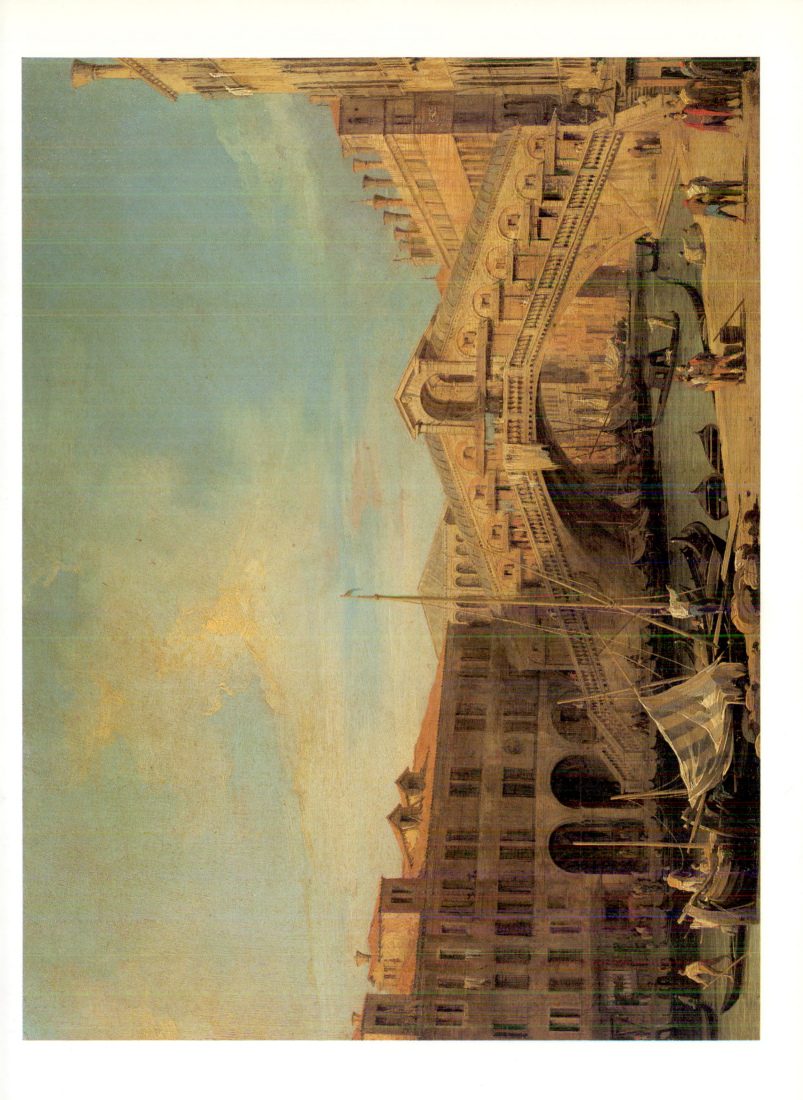

Grand Canal: 'The Stonemason's Yard'; Santa Maria della Carità from the Campo San Vidal

*c*1728. Oil on canvas, 124 x 163 cm. National Gallery, London

In many of Canaletto's depictions of Venice he shows the public face of the city – the façades of its grandest buildings and civic pageants. But in this painting, which some consider his masterpiece, the intention is quite different and altogether more subtle. Here we are allowed a view of a quiet square where work continues and the small dramas of everyday life are enacted, far from the tourist spectacles of the great Piazza and San Marco.

The Campo San Vidal is in the foreground, with beyond it the Grand Canal, and on its far side the church of Santa Maria della Carità, which in the nineteenth century was converted into the city's Accademia delle Belle Arti. The square is cluttered with pieces of Istrian stone, and blocked by a workman's hut – all evidence of the stonemasons' toil for the nearby, although unseen, church of San Vidal. Potted plants are carefully placed on balconies, washing is strung between buildings, wisps of smoke emerge from a chimney, and the tools of the workmen are all carefully defined. A tumbling child draws the attention of its mother and a neighbour looks down on the scene, while elsewhere a figure can be seen spinning in the sunshine.

All of this anecdote and informality is contained within a composition of lucid and almost monumental structure. It is, though, by no means too rigidly imposed; variation is provided by the slanting shadows and rhythm of the skyline, as well as the constantly shifting textures and hues of the buildings – crumbling russet plaster, dark brick and honeyed timber.

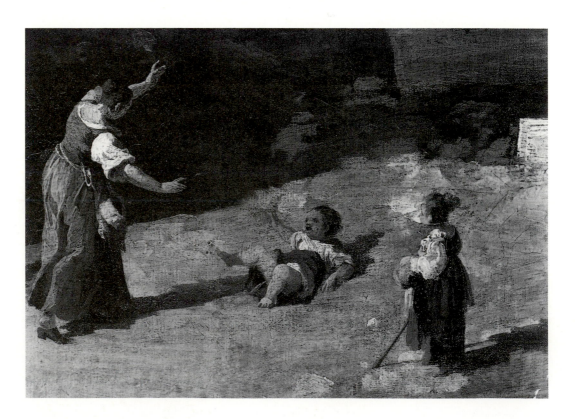

Fig. 19
Detail from Plate 8

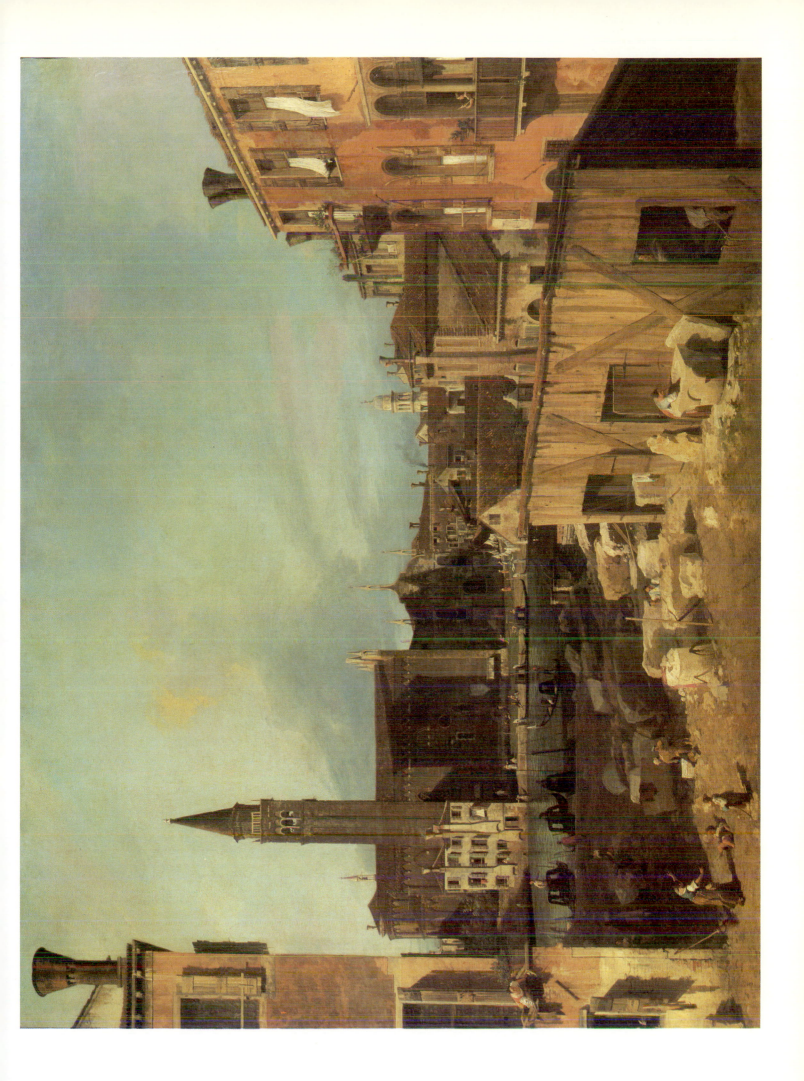

9

Piazza San Marco: the Clocktower

*c*1730. Oil on canvas, 52.7 x 70.5 cm. Nelson-Atkins Museum, Kansas City, MO

In the centre of the composition is the Torre dell'Orologio (clocktower) which was designed by Mauro Codussi (1496-99). Above the clock face is a sculpture of the Madonna, and on the very top of the tower are the two bronze figures, called the 'Mori', which strike the hours. On the left of the painting is the Loggetta at the base of the Campanile and at the right the façade of San Marco.

The buildings are depicted accurately and in some considerable detail. Such precision contrasts with the liquid freedom of the application of paint used to place the cloud forms above. The figures in the foreground include oriental traders, shoppers, vagrants, servants, children and a youth who reclines nonchalantly in the sunshine.

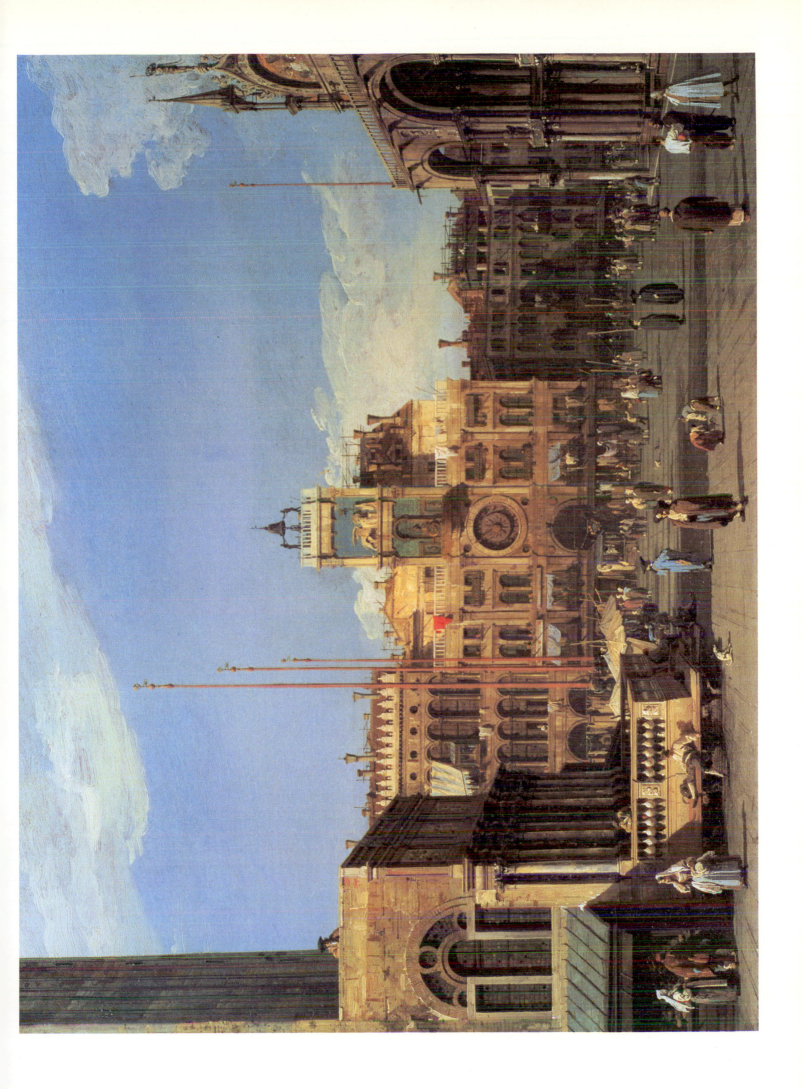

1730. Oil on canvas, 55 x 102 cm. Tatton Park, Cheshire, National Trust

This work and its companion picture (Plate 11) were painted for Samuel Hill, who came from Staffordshire. They are of considerable interest as accomplished view paintings of the early 1730s, but are also significant because in the correspondence related to their commission the agent Joseph Smith for the first time mentions Canaletto's name. Smith wrote a letter dated 17 July 1730 to Hill, in which he stated:

> At least I've got Canal under articles to finish your 2 peices [*sic*] within a twelvemonth; he's so much follow'd and all are so ready to pay him his own price for his work (and which he vallues himself as much as anybody)...nor is it the first time I have been glad to submitt to a painter's impertinence to serve myself and friends...

Smith gives the impression that Canaletto was very popular and somewhat egotistical; his popularity should not be doubted, but the question of his character needs to be approached with caution. It may well be the case that Smith felt the need to present Canaletto as a difficult man in order to justify his role as an intermediary between Hill and the painter.

Samuel Hill's nephew, Samuel Egerton, worked for Smith. He eventually inherited his uncle's estate, including Tatton Park in Cheshire, which is where the two paintings can still be seen.

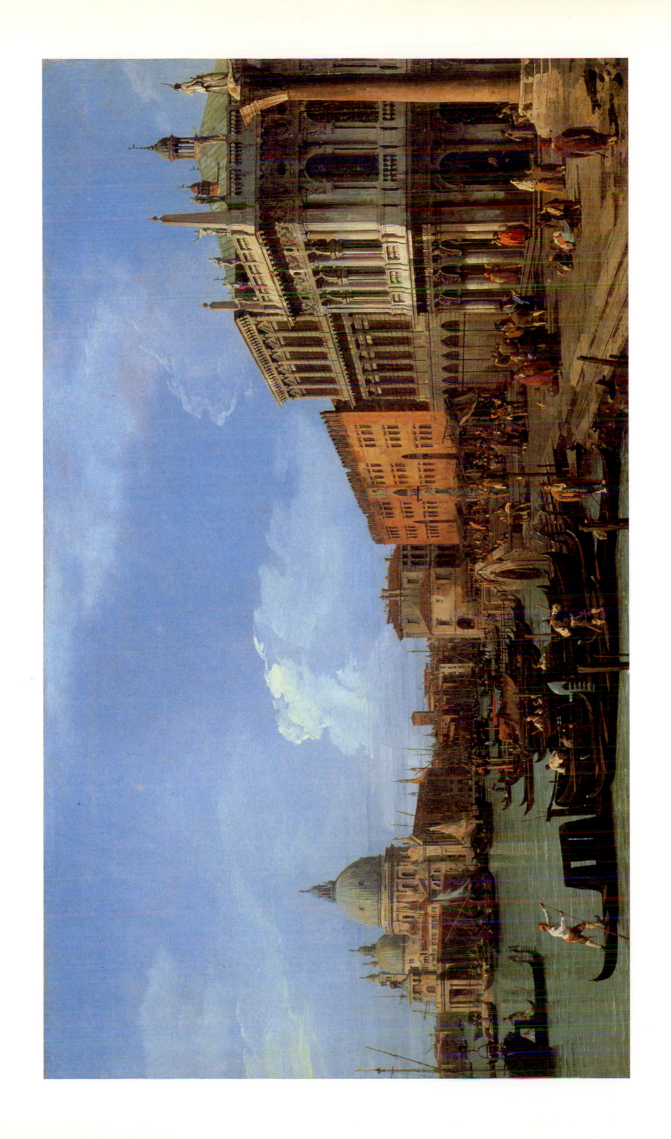

1730. Oil on canvas, 58.4 x 101.6 cm. Tatton Park, Cheshire, National Trust

The compositions of this work and its companion picture (Plate 10) complement each other very effectively; they both show dominant buildings in the foreground to one side of the picture, from which the eye meanders both across the painting and into the distance. Their subjects are also complementary; they depict views of the waterfront on either side of the Molo, the seaward part of the Piazzetta. In this painting the view extends from the Doge's Palace right along the quay known as the Riva degli Schiavoni. Boats of all sizes throng the water, and Venetians are shown either in the lofty pursuit of trade and politics (a group of officials energe from the Doge's Palace), or the equally fascinating, although more down to earth business of begging and gossiping. The other painting shows the view from the Column of San Teodoro over towards Santa Maria della Salute on the far side of the Grand Canal.

These subjects became extremely popular and were rethought by Canaletto and his studio with small variations for a number of other clients. Canaletto executed related drawings (see Fig. 20) which both he and his assistants could use as a guide when plotting these views.

Fig. 20
Venice: Riva degli
Schiavoni
Early 1730s. Pen and ink
over pencil on paper,
19.6 x 30.9 cm.
Royal Collection

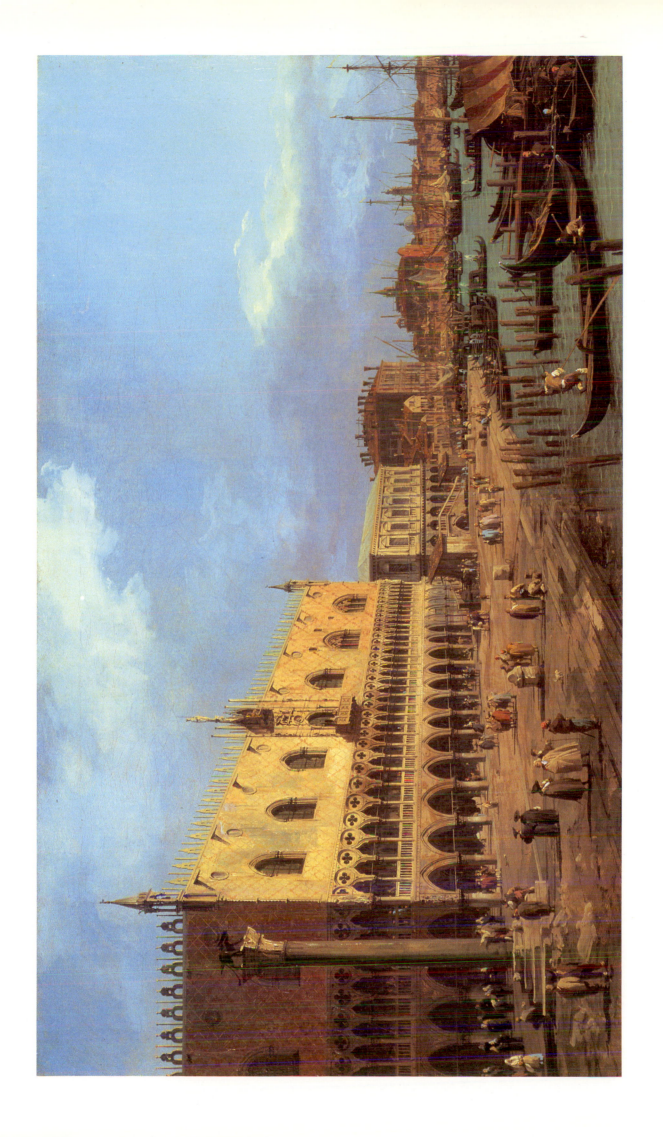

A Regatta on the Grand Canal

*c*1732. Oil on canvas, 77 x 126 cm. Royal Collection

Venice's reputation as a city of festivities was amply justified. This painting, along with its companion picture, Plate 13, record two of the most spectacular. Here a gondola race which formed part of a Regatta held on the Grand Canal is depicted. Such events had been organized since the fourteenth century as part of the Carnival, and were also occasionally arranged to honour notable visitors to the city.

At the extreme left of the picture is the *macchina* (an ornate temporary structure) under which the winners of the races were presented with flags. It bears the coat of arms of Carlo Ruzzini who ruled as Doge of Venice from 1732 until 1735. Spectators fill boats along either side of the Grand Canal, and observe the race from the balconies of the palaces, many of which are decorated with hangings. The eight-oared barges have been specially decorated for the occasion, and a number of the figures, notably in the foreground, wear Carnival costumes, such as the tricorn hat with a white mask and black cape.

An engraving of this work was included in Canaletto's *Prospectus* series of 1735. The composition was clearly popular – other similarly accomplished versions of it are in the collections of Woburn Abbey and the National Gallery, London.

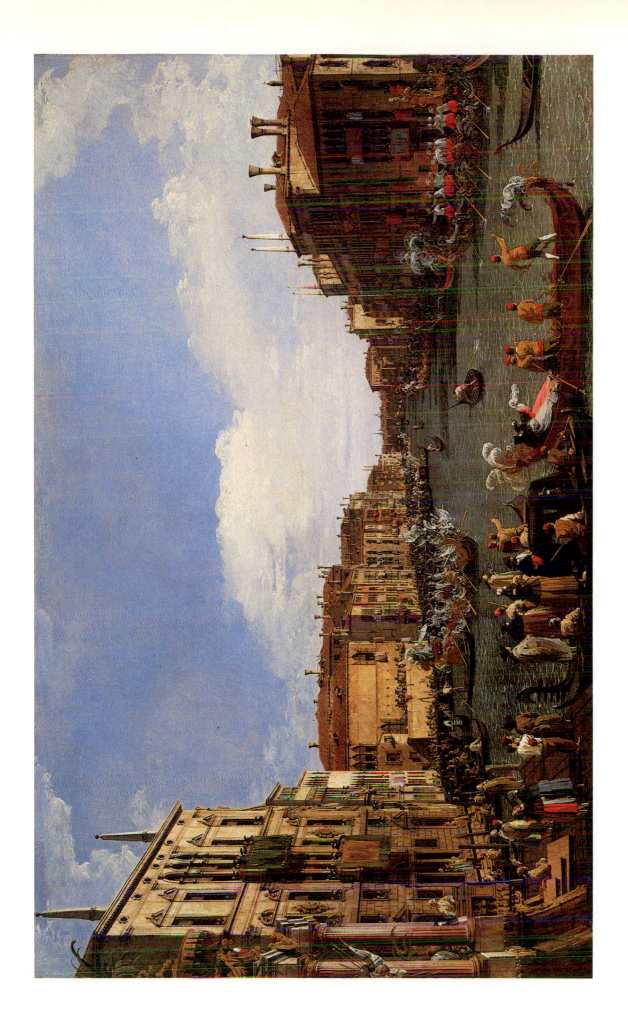

*c*1732. Oil on canvas, 77 x 126 cm. Royal Collection

The historical power of the Venetian Republic was dependent upon its mastery of the sea, both for trading and military purposes. Such dominance had waned by the eighteenth century, but past glories were symbolically recalled in ceremonies, such as the one depicted in this work.

Here, a naval victory over Dalmatia which took place in 998 AD, apparently on Ascension Day, is commemorated. During the event the Doge travelled in the Bucintoro, the golden barge, out into the Lido, where he cast a ring into the sea, as a symbol of the marriage or union between Venice and the Adriatic. Such a ring had been given to a twelfth-century Doge by the Pope in gratitude for his peacemaking.

The massive barge, designed by Stefano Conti and the last to be built before the fall of the Republic, has just returned from the Lido. The spectacle it creates, with its huge, brilliant orange flag fluttering before the sky, was clearly one that appealed to Canaletto. It is perhaps the archetypal Venetian scene, combining as it does elements of beauty, showiness, symbolism, and sheer delight in the physical appearance of the city.

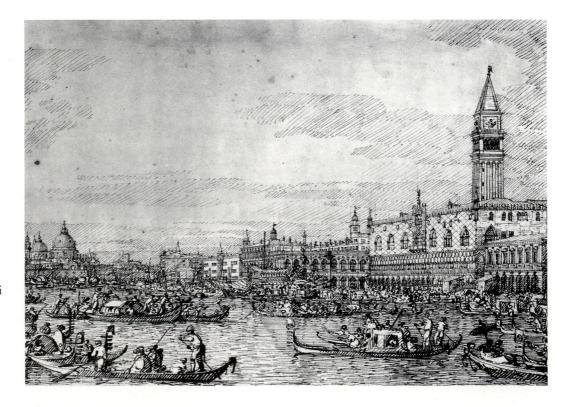

Fig. 21
Venice: The Canale di San Marco with the Bucintoro at Anchor
Early 1730s. Pen and ink over pencil on paper, 26.8 x 37.6 cm.
Royal Collection

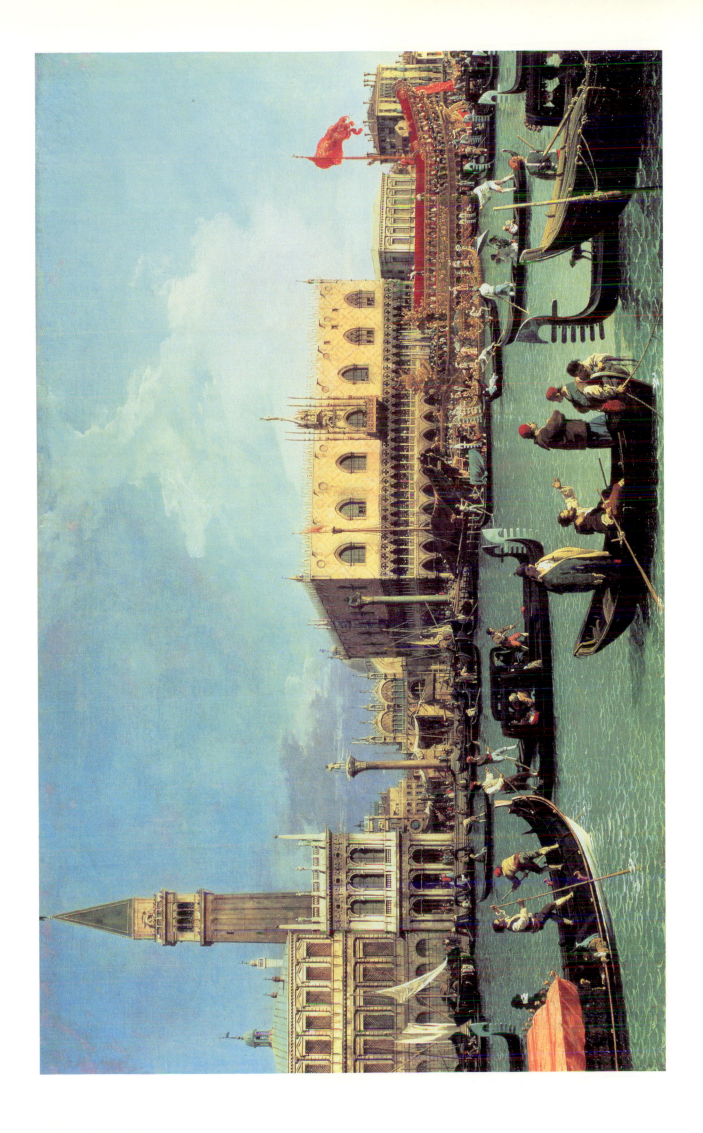

*c*1732. Oil on canvas, 47 x 78.8 cm. Woburn Abbey, by kind permission of
The Marquess of Tavistock

The powerful Venetian fleets were built in the city's Arsenal, or naval
boatyard, which had been established in the twelfth century. This view
shows its water entrance, with dry docks and a ship inside, and to the left
the Great Gateway which was built in 1460.

Canaletto followed the preparatory composition he established on
paper (Fig. 22) in the painting in most respects, although in the latter he
placed the two towers either side of the entrance further apart. The
diagonals of the wooden footbridge in the foreground effectively vary and
break up what would otherwise be a very static composition based upon
vertical and horizontal emphases.

The painting is one of 24 works by Canaletto bought by the 4th Duke
of Bedford which remain together at Woburn Abbey.

Fig. 22
The Arsenal: the
Water Entrance
Early 1730s. Pen and ink
on paper, 27.1 x 37.2 cm.
Royal Collection

15　Grand Canal: from Santa Maria della Carità to the Bacino di San Marco

Early 1730s . Oil on canvas, 47.9 x 80 cm. Royal Collection

In the central distance can be seen the dome of the Salute and the masts of a number of large ships moored in the Bacino, while at the right is the church of Santa Maria della Carità, which also features prominently in 'The Stonemason's Yard' (Plate 8). It was converted into the city's art gallery – the Accademia delle Belle Arti – in the nineteenth century. This view looks very different today because the foreground is dominated by the modern Accademia bridge and the bell tower no longer exists. The appearance of the impressive palace on the far side of the canal, the Palazzo Cavalli, has also been altered.

This painting is a good illustration of Canaletto's achievement as a subtle colourist; he has effectively contrasted the powder-blue sky with the green water and the tan and orange brickwork and roof-tiles. In addition he has created formal interest by carefully observing how the Scuola to the far right of the picture casts diagonal shadows across the façade of the church. This work was owned by Joseph Smith and while in his collection it was engraved by Visentini as part of the *Prospectus Magni Canalis* series of prints.

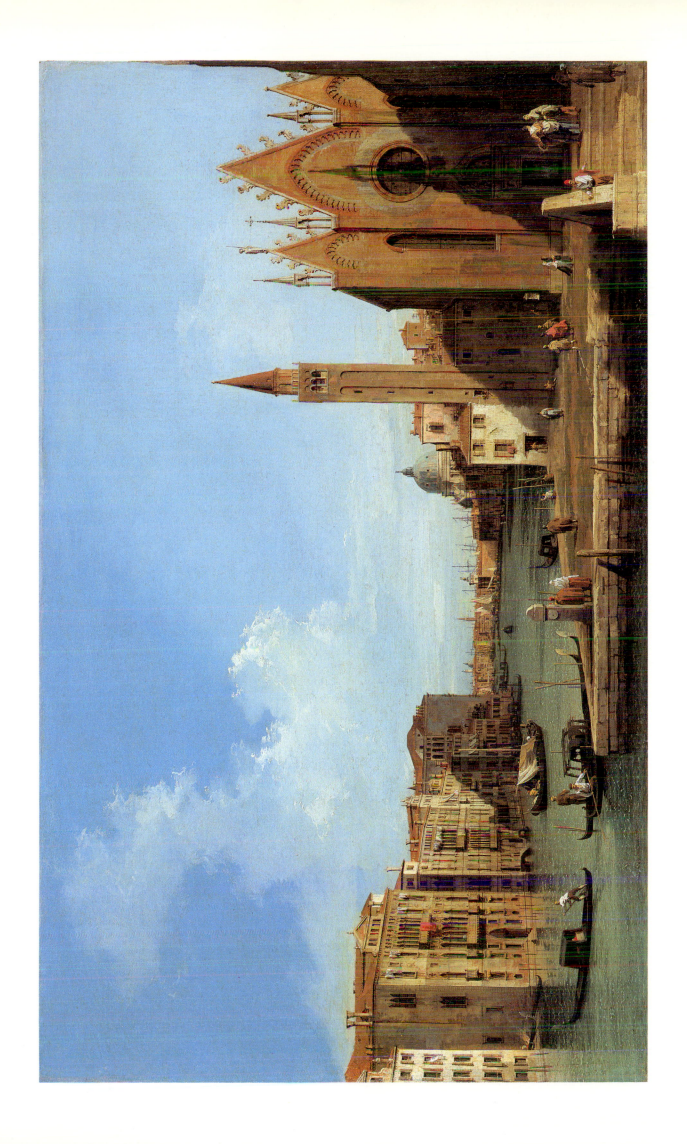

The Doge Visiting the Church and Scuola di San Rocco

*c*1735. Oil on canvas, 147 x 199 cm. National Gallery, London

Fig. 23
Detail from Plate 16

The church of San Rocco at the right has housed the body of St Roch since 1485. In 1576 there was a very severe outbreak of the plague in Venice, and it was thought that his intercession prevented an even greater calamity, so from that year onwards his Feast day, 16 August, was celebrated by the Republic. Canaletto here depicts one aspect of the festivities – a procession of resplendent dignitaries emerging from the church after they have attended Mass.

The Scuola di San Rocco dominates the centre of the composition; its exterior is decorated with garlands and paintings, as was the custom on this occasion. Canaletto and his artist nephew Bellotto are recorded as having sold some of their works at one of these exhibitions (see Plate 5). Many of the figures walking before it and beneath the awning can be identified because of their distinctive and colourful clothes. They are, from left to right: Secretaries, who wear mauve; the Doge's chair- and cushion-bearers; the Cancelliere Grande who wears scarlet; the Doge himself in gold and ermine; the Guardiano Grande di San Rocco; the bearer of the sword of state; the Senators; and finally the Ambassadors. A number of them carry nosegays, which were presented as reminders of the plague; they were carried during outbreaks of the disease because it was believed that their scent helped prevent its spread.

Canaletto shows an expansive view of this scene which could not, in fact, be observed, because the church of the Frari impinges too far on the near side of the square.

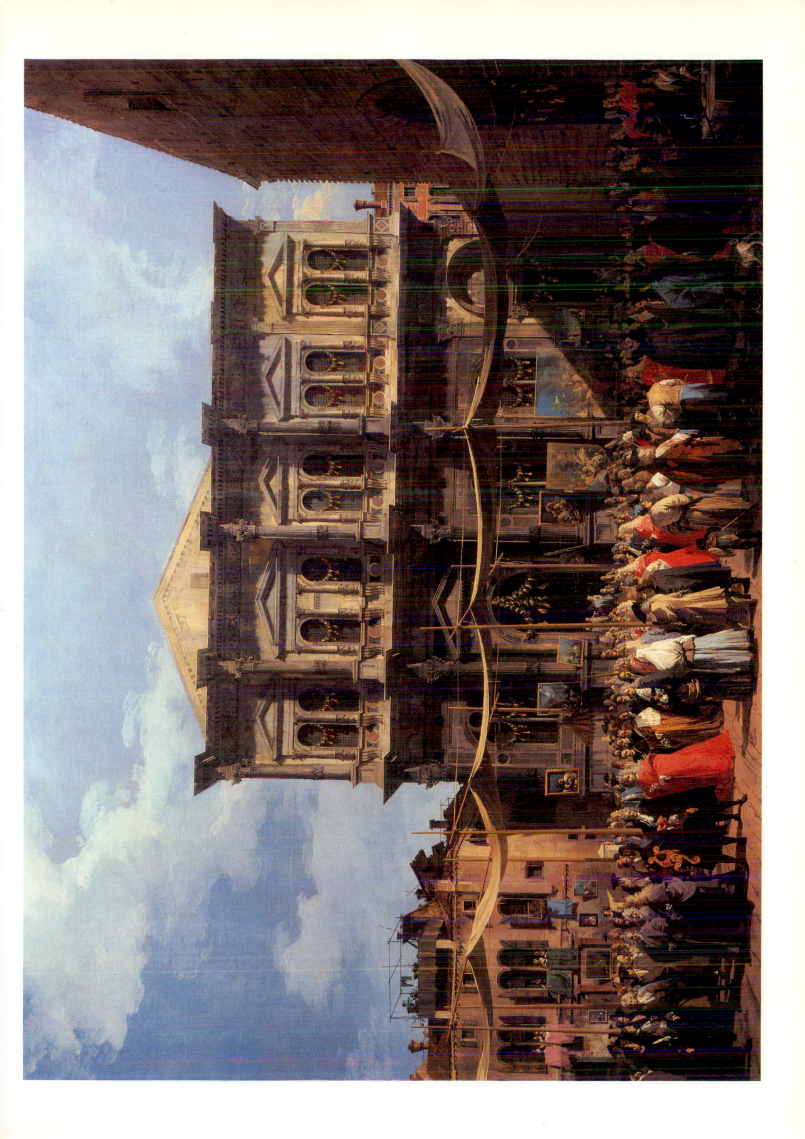

1735-40. Oil on canvas, 114.2 x 153.5 cm. National Gallery of Art, Washington DC

Together with Plate 18, this view of the Piazza San Marco is thought to have been bought by the Earl of Carlisle, directly from Canaletto himself. Both works hung in Castle Howard in Yorkshire, one of the homes of the Carlisle family, until they were sold earlier this century. They were presented to the National Gallery in Washington by Barbara Hutton in 1945.

The Piazza is here shown as a lively centre of commerce; stallholders cluster round the flag staffs and are protected from the sun by large colourful parasols. From left to right an impressive view of the San Marco, the Doge's Palace and a view of the Bacino, forms a backdrop to their activity. From this vantage point the artist shows a clear view of horses of San Marco which are set above the main door of the church; they were later to become the subject of one of Canaletto's most inventive *capricci* (Plate 25).

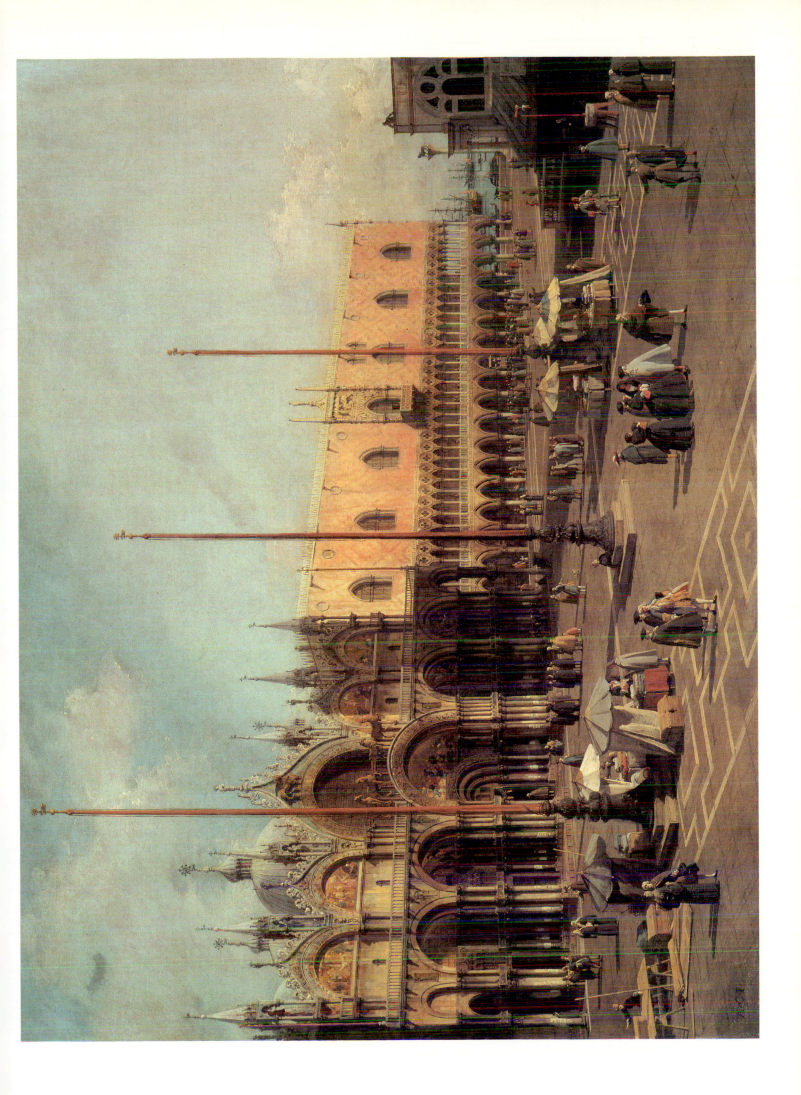

Entrance to the Grand Canal: from the West End of the Molo

1735-40. Oil on canvas, 114.5 x 153 cm. National Gallery of Art, Washington DC

This is one of the relatively few works that Canaletto signed; he has inscribed the initials A.C.F. on the low wall in the foreground. They stand for *Antonio Canal Fecit* (Antonio Canal made this). Close to the inscription are various traders selling seafood, and beyond it, to the right, is a neat row of gondolas.

The Molo is the busy area of waterfront on the seaward side of the Piazzetta. From this section of it is possible to get a splendid view of the church of Santa Maria della Salute and the customs house on the far side of the Grand Canal. Further to the left can be seen Palladio's church of the Redentore, which dominates the Giudecca.

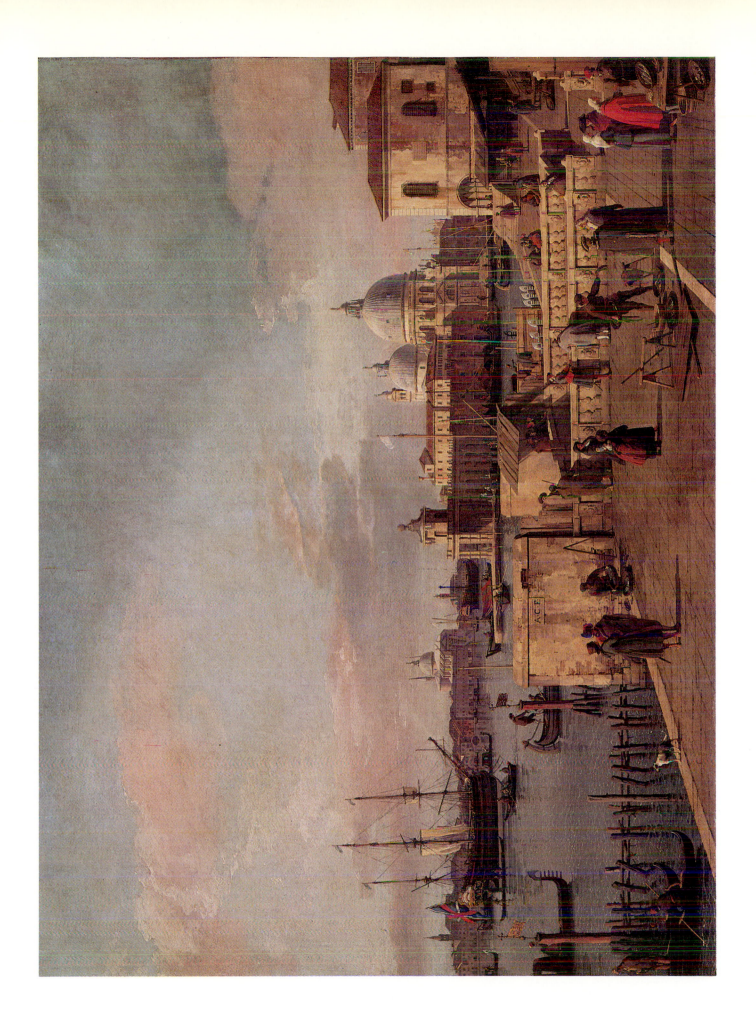

19 Grand Canal: looking South-West from the Chiesa degli Scalzi to the Fondamenta della Croce, with San Simeone Piccolo

*c*1738. Oil on canvas, 124 x 204 cm. National Gallery, London

The church of San Simeone Piccolo, at the left, was rebuilt between 1718 and 1738 after a design by the architect Scalfarotto. It is depicted here completed, hence the dating of the painting to about 1738. Canaletto had earlier painted other versions of the same composition, including a picture in the Royal Collection which was engraved by Visentini as part of the *Prospectus Magni Canalis* series of prints.

This view of the upper reaches of the Grand Canal is now considerably altered by the city's modern railway station which dominates and disrupts its right side. The artist has depicted some craft plying their way across the canal, including a passenger barge at the left, but the scene is a relatively peaceful one. He seems to have been particularly preoccupied with the gently distorted mirror-image of the buildings reflected on the surface of the water.

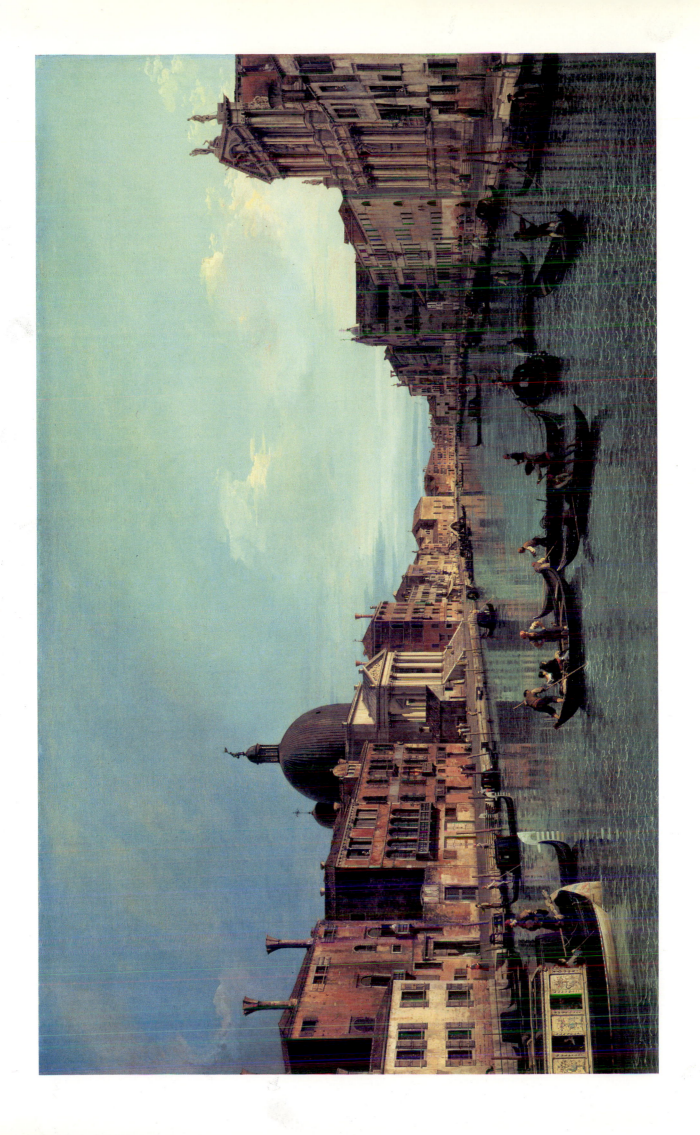

Dolo on the Brenta

Late 1720s-1742. Oil on canvas, 80 x 95.3 cm. Staatsgalerie, Stuttgart

During the early 1740s Canaletto sought new subjects for his work. He travelled along the Brenta canal towards Padua (a journey of about 40 kilometers) with his nephew, the artist Bernardo Bellotto, and made a number of studies which were to form the basis of paintings and prints. The subject of this painting, Dolo, a small village on the canal, would seem to link it with this journey, but stylistically the picture does not fit comfortably with other paintings of the period. It shares some of the charm of Canaletto's works of a decade earlier which show a fresh and engaging interpretation of scenes unfamiliar to most visitors to the Veneto. For this reason it may well be the product of an earlier undocumented sketching trip.

The view of the canal is towards the east. In the foreground is a sluice-gate, while at the left can be seen the bell tower of the church of San Rocco, and at the right boatyards. In the centre of the canal is a passenger barge, of the type Canaletto probably used to travel to Padua.

There seems to be a pointed contrast between the rich dresses of the ladies in the left foreground and the dull rags worn by a number of the other figures. It is unlikely that Canaletto was making a social comment here on the distinctions between social classes, but more probable that he placed the women in their attractive gowns as a pictorial device. The white and pink of their outfits seem to act as a necessary counterpoint to the brilliant blue of the sky.

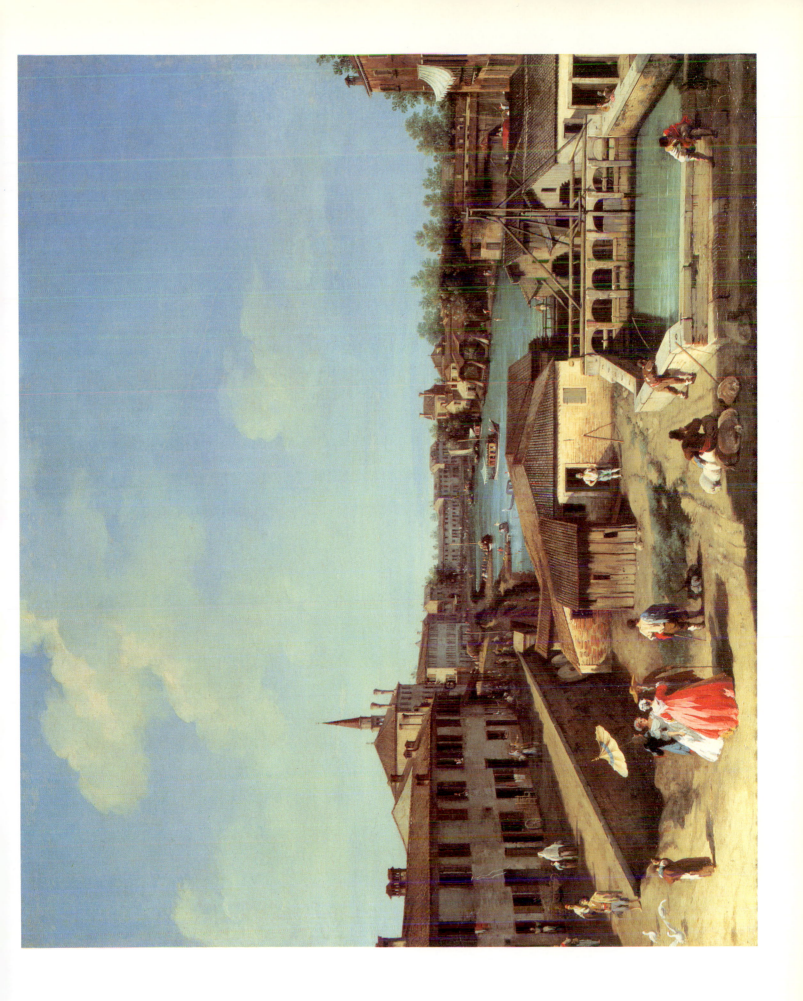

Capriccio: Ruins and Classic Buildings

1730s. Oil on canvas, 87.5 x 120.5 cm. Museo Poldi Pezzoli, Milan

Capricci are paintings in which Canaletto drew on his studies of identifiable sites and buildings, but combined them in an imaginative form to create a very consciously fictional and poetic image. Here he has brought together different architectural elements which seem to be both Roman and Paduan in inspiration. The dome on the horizon is reminiscent of that of St Peter's in Rome.

Many versions of this composition exist and not all of them can be by Canaletto. The fact that such images were reproduced illustrates that there was a ready market for works of this type. In part they were inspired by the classical landscapes of the seventeenth century, but they also were conceived to appeal to the cult of ruins which developed during the eighteenth century – a trend fed by antiquarianism, archaeology and nostalgia.

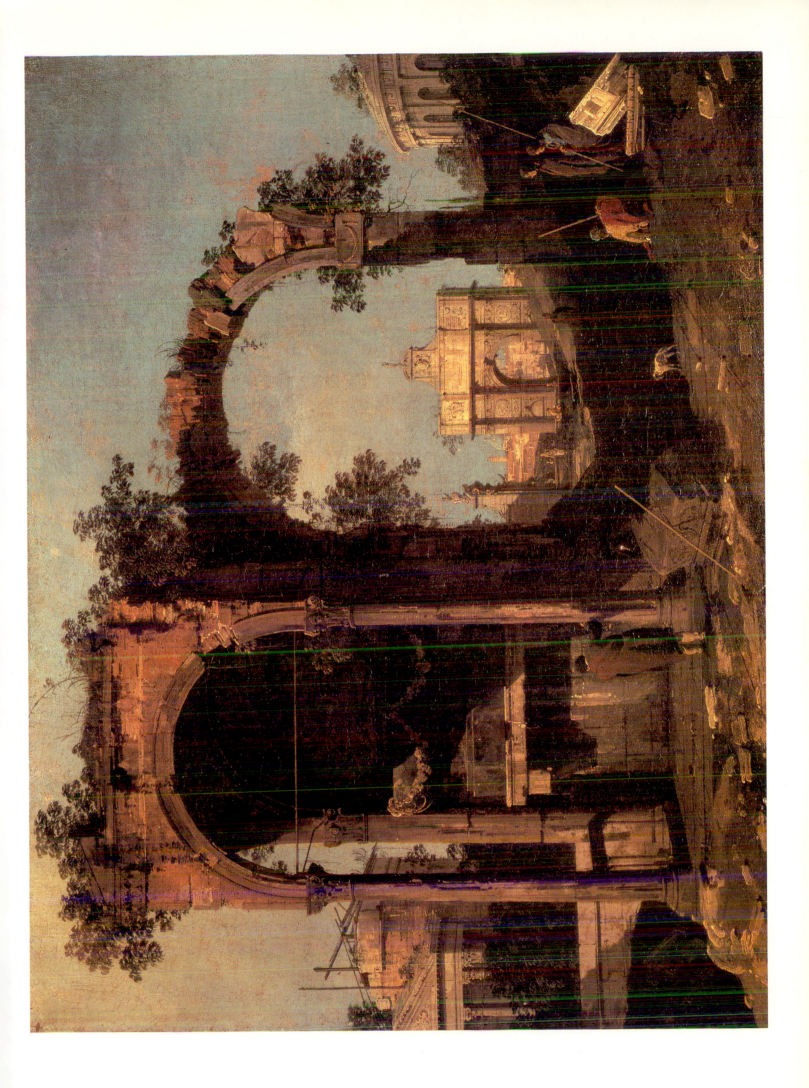

Rome: the Arch of Constantine

1742. Oil on canvas, 181.5 x 103 cm. Royal Collection

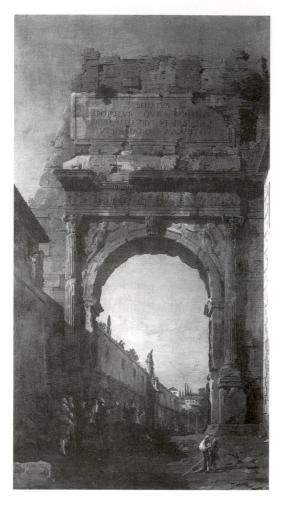

This is one of a series of five impressive paintings of Roman subjects that Canaletto executed for Joseph Smith. It is not entirely clear whether they were based on a new visit to Rome, or sketches the artist had made there in 1720. It is possible that he could additionally have been inspired by prints of Roman subjects in Smith's collection.

The arch was built by the Emperor Constantine in the fourth century, to commemorate his victory over Maxentius. The view is playfully manipulated; the friezes and inscriptions he chose to depict are those which can be seen on the north side, but it is painted as though looked at from the south. Through it can be seen the church of San Pietro in Vincoli, and to the right the edge of the Colosseum. The main group of figures in the foreground, one of whom points with his stick, are probably Grand Tourists who have come to admire the ancient glories of the city.

The seated figure at the left, who has beside him a portfolio and ruler and is either writing or drawing, may well be intended as a self-portrait. This is particularly suggested by the figure's proximity to Canaletto's rather grand inscription asserting his authorship and the date of the painting, in a manner that replicates the carvings on the arch.

Fig. 24
The Arch of Titus
1742. Oil on canvas,
190 x 104 cm.
Royal Collection

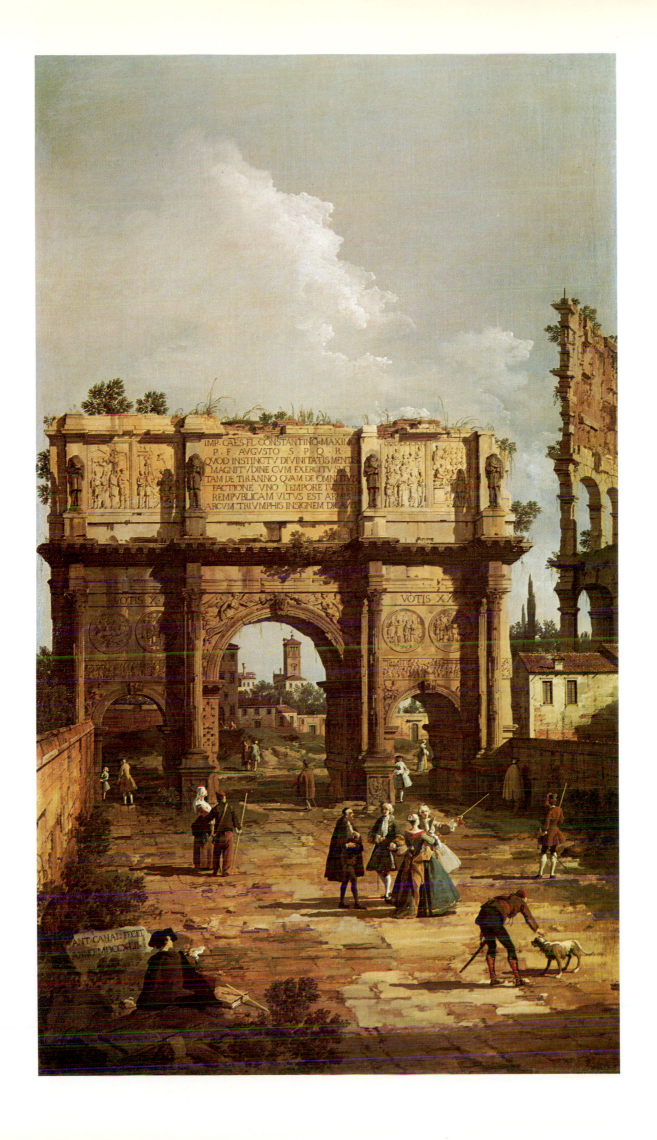

23 Rome: Ruins of the Forum, looking towards the Capitol

1742. Oil on canvas, 188 x 104 cm. Royal Collection

This attractive view of the Forum comes from the same series of paintings as Plate 22. Like the other three works from the group it is prominently signed and dated.

The Forum was the site of the political and religious centre of ancient Rome; attempts to excavate it were made throughout the eighteenth century, and the ruins revealed were consistently revered by visitors to the city. The tourists shown here mainly scrutinize the remains of the temple of Castor and Pollox which dominates the foreground. One man, at the right, is so intent upon the ruin that he appears to be ignoring the cleric in black who is attempting to converse with him. Further back, at the left, between the columns can be seen a knife grinder, and over towards the right, the Temple of Saturn. Rising up above it is the Palazzo Senatorio which dominates the Capitoline Hill. These topographical elements have been depicted with considerable care, but elsewhere the artist has taken liberties with his subject – some of the houses at the left are invented, and their chimneys appear characteristically Venetian, rather than Roman.

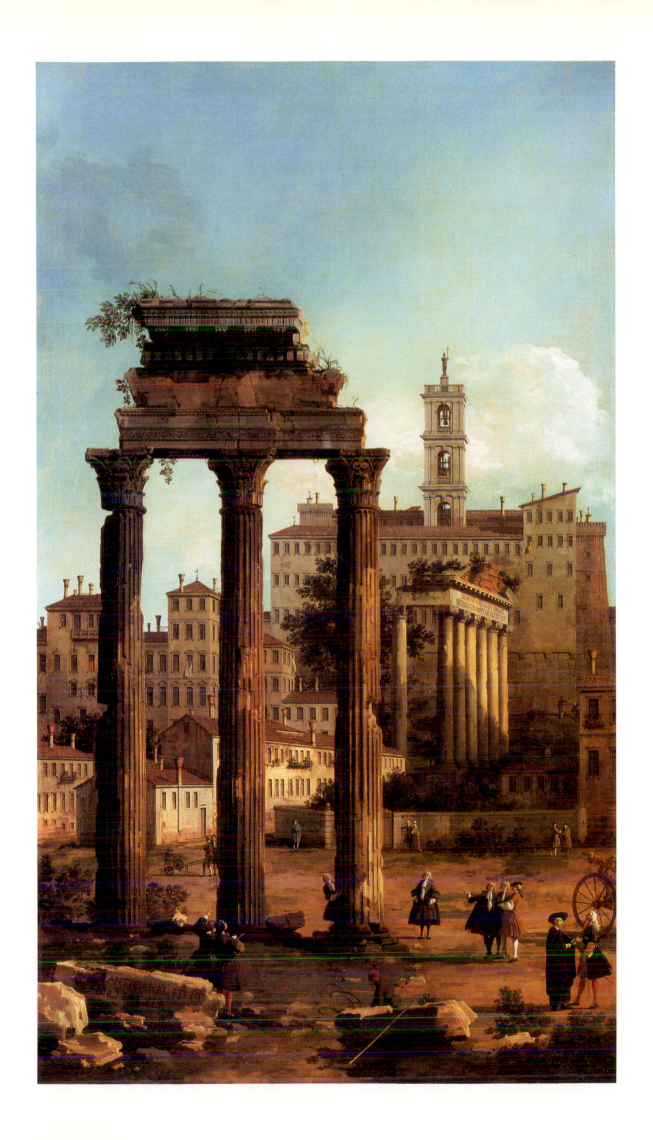

24 Capriccio: the Ponte della Pescaria and Buildings on the Quay

1742-4. Oil on canvas, 84.5 x 129.5 cm. Royal Collection

In the early 1740s Canaletto painted a series of 13 canvases which were described in early inventories as 'overdoors', in other words pictures intended to be set above doorways as part of a decorative scheme. They placed a particular emphasis on the works of the architect Palladio. Joseph Smith, for whom they may have been made, is known to have particularly favoured Palladian themes. Three works from the series are illustrated here: Plates 24, 25 and Fig. 25.

This austere *capriccio* is actually one of weakest of the 'overdoors' in terms of quality, but nonetheless of interest. The very fact that it is poorly executed is a useful reminder of Canaletto's practice of employing assistants; he would probably have planned the composition, and then perhaps because of a need to finish the commission quickly allowed a member of his studio to carry out most of the work.

The view is shown as though seen from the Bacino: at the left are the state granaries, and to the right the Zecca, or Mint. Between them is the Ponte della Pescaria, and beyond, the rear of the Procuratie Nuove. The artist has made the little bridge look more theatrical and impressive by depicting on it statues by Aspetti and Campagna which are in reality at the entrance to the Biblioteca Marciana.

Fig. 25
Capriccio: a Palladian
Design for the Rialto
Bridge
1742-4. Oil on canvas,
90 x 130 cm.
Royal Collection

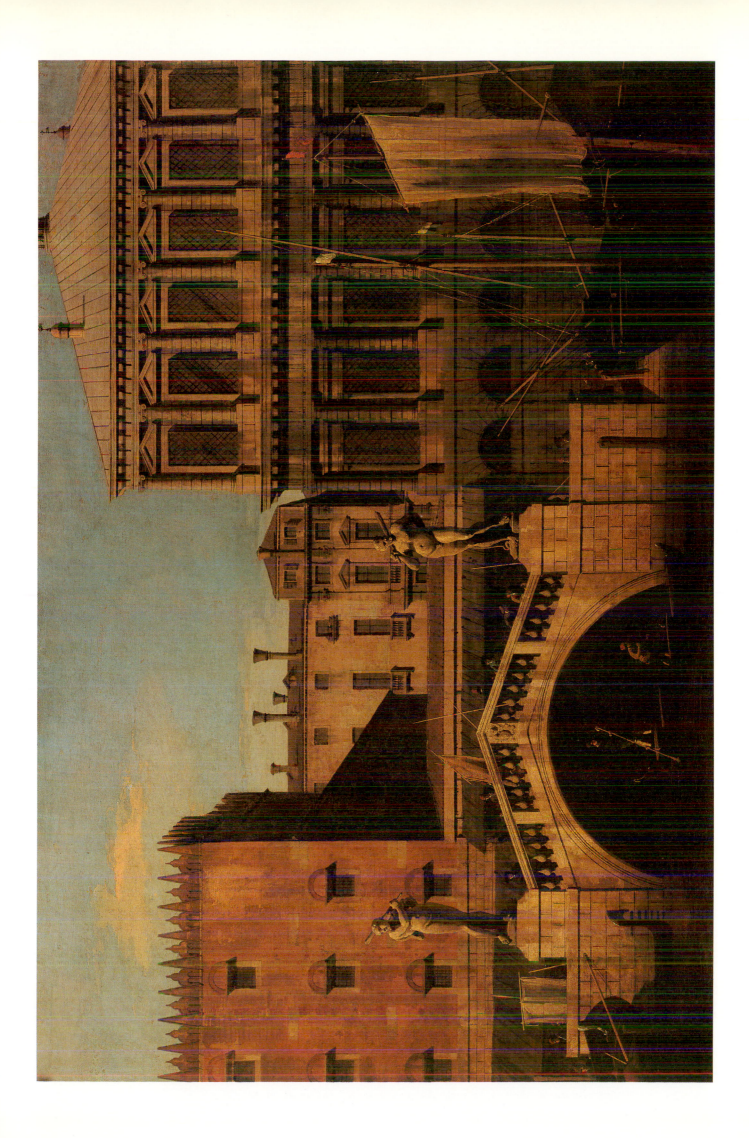

Capriccio: the Horses of San Marco in the Piazzetta

1743. Oil on canvas, 108 x 129.5 cm. Royal Collection

The gilded bronze horses of San Marco are one of the great treasures of Venice. They are thought to be ancient, although their precise origin and date remains a matter of scholarly debate. It appears they were taken from Constantinople when the city was sacked by the Venetians in 1204.

In the 1740s the horses were above the *loggia* at the entrance to San Marco. They were only removed from this position in 1798 when Napoleon's troops overtook the city and were then taken to Paris, but returned to Venice in 1815.

The dramatic arrangement of these horses on pedestals is entirely fictional. It is possible that it is intended to convey the frustration felt by many at not being able to study the horses properly above the *loggia*. For example, the Neo-classical sculptor, Antonio Canova (1757-1822), suggested that they should be set either side of the entrance to the Doge's palace so that they could be seen to better advantage.

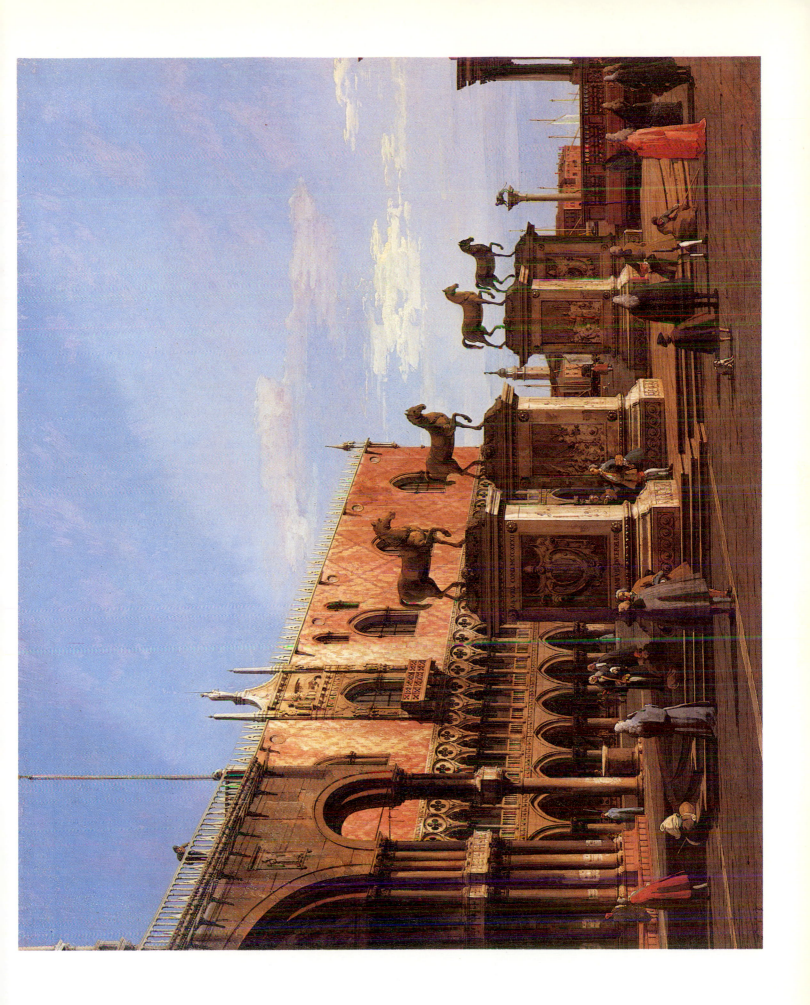

Capriccio: the Grand Canal, with an Imaginary Rialto Bridge and Other Buildings

1740s. Oil on canvas, 60 x 82 cm. National Gallery, Parma

In this work and its companion picture (Fig. 26) Canaletto created two of his most complex and intriguing *capricci*. He had already depicted an unrealized scheme for the Rialto Bridge, but in these works went one stage further and painted alternatives to the actual bridge surrounded by a sophisticated and extensive group of invented buildings.

The bridge and extraordinary circular temple at the right appear to be almost entirely imaginary. Such spectacular flights of fancy may at root be based on reminiscences of details in works by Claude Lorraine (1600-82) and Giovanni Battista Piranesi (1720-78), but Canaletto has transformed possible sources of this type into a decorative creation all of his own. In Figure 26, however, it is possible to locate the origin of a number of the buildings. The bridge is the same as the one in Figure 26, and the large structure to the right of it is copied from Andrea Palladio's Palazzo della Ragione in Vicenza. Part of the attraction of these works was clearly spotting such borrowings and in so doing displaying one's knowledge.

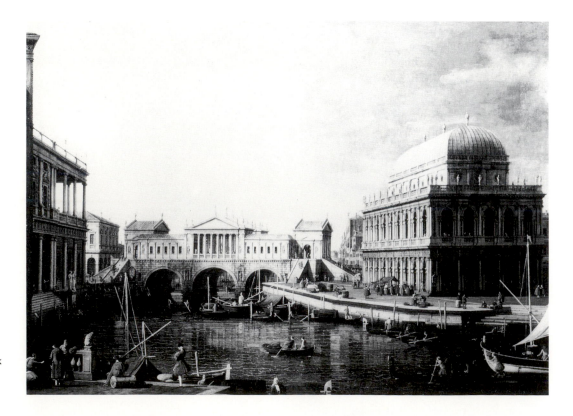

Fig. 26
Capriccio: a Palladian Design for the Rialto Bridge, with Buildings at Vicenza
1740s. Oil on canvas, 60.5 x 82 cm. National Gallery, Parma

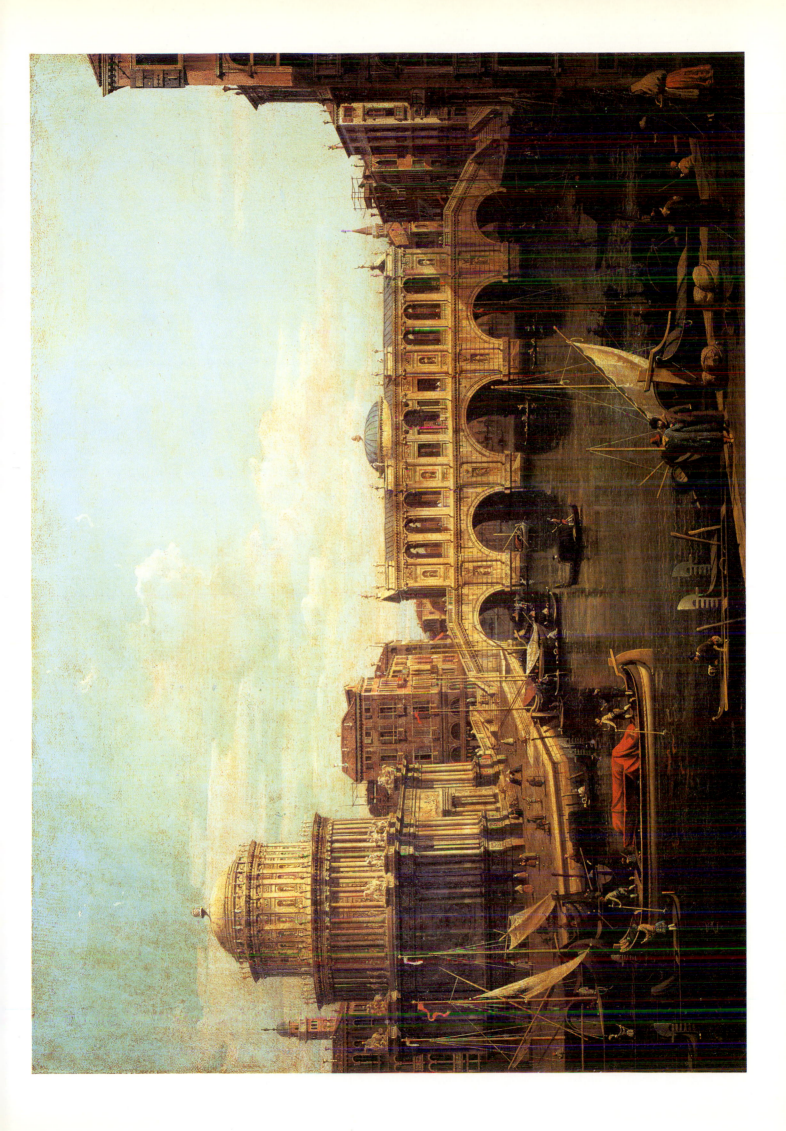

1744. Oil on canvas, 127 x 203 cm. Royal Collection

Scale appears to be the dominant preoccupation in this work. The painting is one of Canaletto's largest, and his intention seems to have been to convey a sense of the immensity of the church of Santa Maria della Salute, at the right.

In his earlier interpretation of the subject (Plate 4) the artist included the whole of the great church, but in this work made the bold decision to crop it at the top, as though to imply that the building could not be contained within one picture. Its enormous size is contrasted with the groups of figures by the waterside: ladies and gentlemen enter the church through one doorway, while a senator, dressed in red, emerges from another.

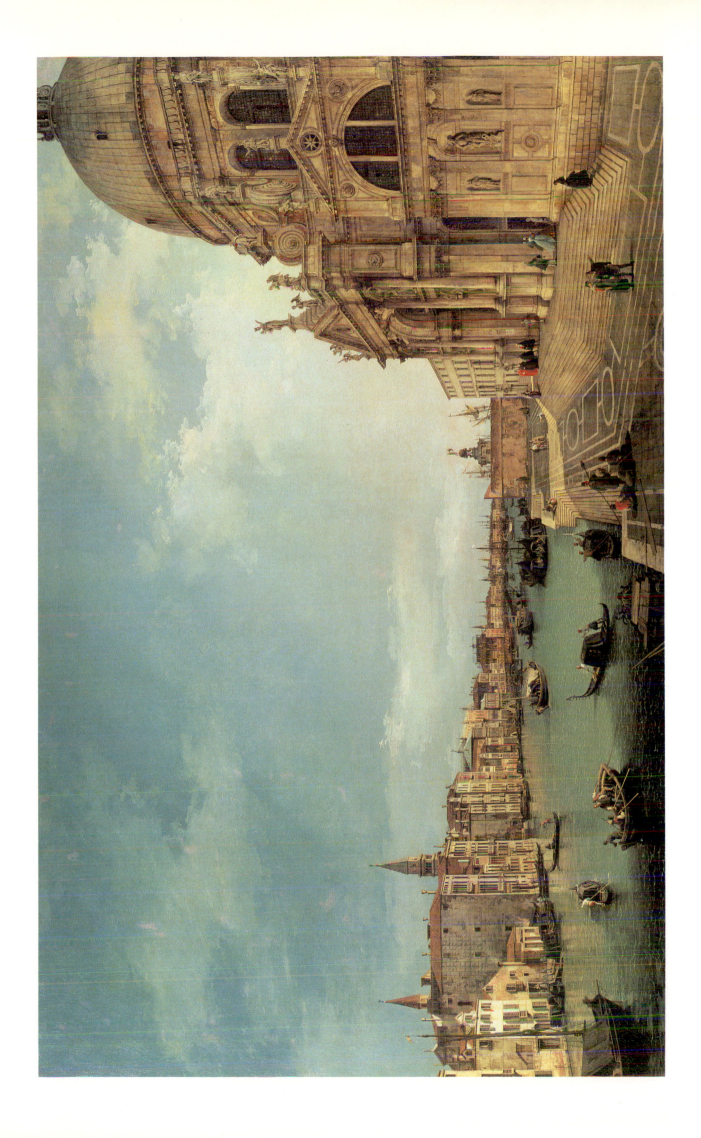

London: Westminster Bridge from the North on Lord Mayor's Day

1746. Oil on canvas, 96 x 137.5 cm. Yale Center for British Art, New Haven, CT

Canaletto is first recorded in England in spring 1746, and his earliest paintings of London are depictions of the new Westminster Bridge, a subject he was to portray from various vantage points (see Fig. 27 and Plate 29). The bridge was not actually completed until four years after this work was painted.

In this picture he combines a view of its whole span with a depiction of festivities, which, although tamer than the Venetian spectacles he generally painted, partially recall them. The celebrations accompanied the appointment of the new Lord Mayor of London. The largest City Barge is shown taking him to Westminster Hall, by the Abbey at the right, where he will be sworn in. The prominent building on the horizon to the left of it is St John's Church, Smith Square, and over on the other side of the river is Lambeth Palace, the London home of the Archbishop of Canterbury. All the other spectacular barges are those of the different city guilds (Skinners, Goldsmiths, Fishmongers, Clothworkers, Vinters, Merchant Taylors, Mercers and Dyers); a number of them are firing salutes to honour the Mayor. In order to encapsulate all of this activity within such a broad panorama Canaletto has adopted an imaginary vantage point high above the Thames.

Fig. 27
London: Westminster Bridge under Repair; from the South-West
1749. Pen and ink with wash on paper, 29.3 x 48.4 cm.
Royal Collection

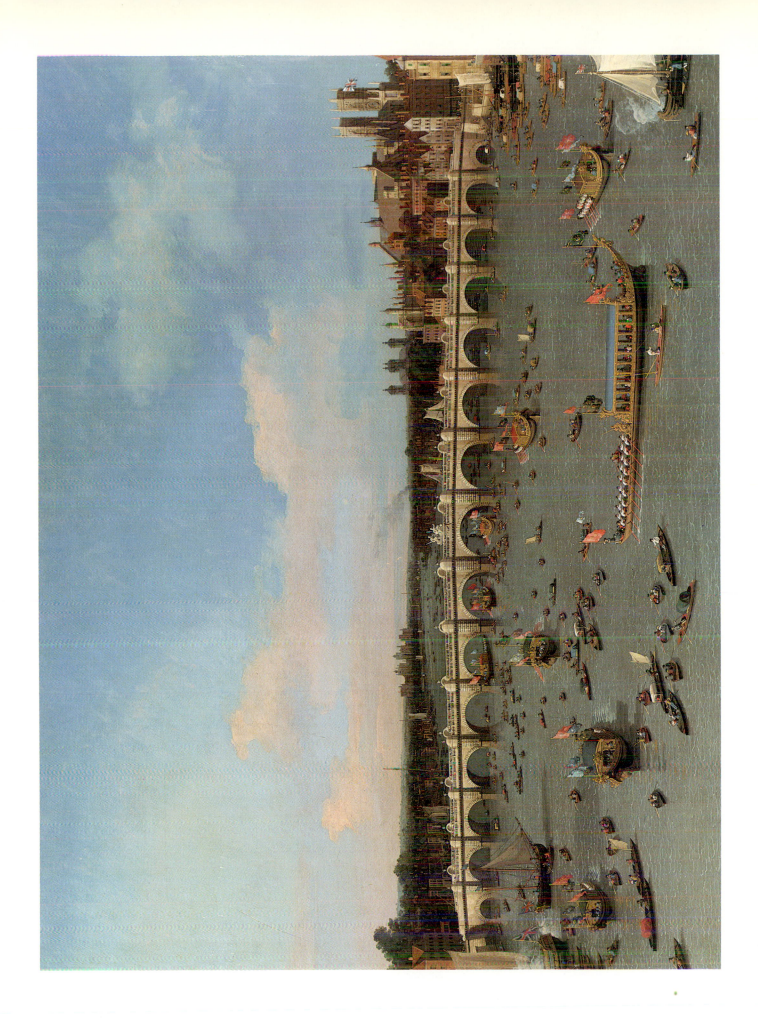

London: seen through an Arch of Westminster Bridge

1746-7. Oil on canvas, 57 x 95 cm. Duke of Northumberland

This very bold composition, with a view of the Thames framed by an arch of the bridge, influenced the work of a number of native English artists. It may have been inspired by a print by Piranesi, published in the early 1740s.

The arch has been used carefully so that it does not flatten the image. It is placed just off centre, looked through at a slight angle, and the uniformity of its shape is broken by the simple device of a bucket being lowered on a rope. It acts like a giant eye or lens and focuses attention on the cityscape beyond, which includes the Water Tower and York Water Gate at the left, and St Paul's Cathedral at the right. In the centre can be seen the spire of the church of St Clement Danes. The delicate peach colouration of the clouds above, suggests this is a rare instance of Canaletto attempting to depict dusk.

The painting is thought to have been commissioned by Sir Hugh Smithson, who was to become the Duke of Northumberland. He was one of those responsible for overseeing the construction of the new bridge.

London: Whitehall and the Privy Garden from Richmond House

1747. Oil on canvas, 106.7 x 116.8 cm. Trustees of Goodwood House, West Sussex

This work and its companion picture (Plate 31), have become the most widely admired paintings executed by Canaletto during his stay in England. They were painted for the Duke of Richmond, and probably based upon sketches made from views from the upper windows of his London home, Richmond House. The Duke himself is depicted with a servant in the courtyard at the lower right.

Whitehall is shown as an open space surrounded by small buildings, unfamiliar to modern Londoners accustomed to vast government offices covering the area. The Tudor Treasury Gate at the left was demolished in 1759 to ease the flow of traffic, but the Banqueting House, left of centre in the middle-distance, and church of St Martin-in-the-Fields beyond and to the right of it, remain.

A sense of order has been imposed on the urban sprall; the main buildings lie parallel to the picture plane, and the perspective is conveniently established by the walls and pathways which run towards the centre of the composition. Everything – from the chickens in the foreground to the houses half a mile away – is observed with a crispness of equal insistence, so creating a vivid record of this unexpected view of the capital during the reign of George II.

Canaletto later reinterpreted the scene from a lower viewpoint (Fig. 28), and produced an even wider panorama (one of his most spectacular), which includes a view of the Thames at the left comparable to that seen in Plate 31.

Fig. 28
London: Whitehall and the Privy Garden, looking North
Probably 1751. Oil on canvas, 118.5 x 273.5 cm. Duke of Buccleuch and Queensberry, Bowhill

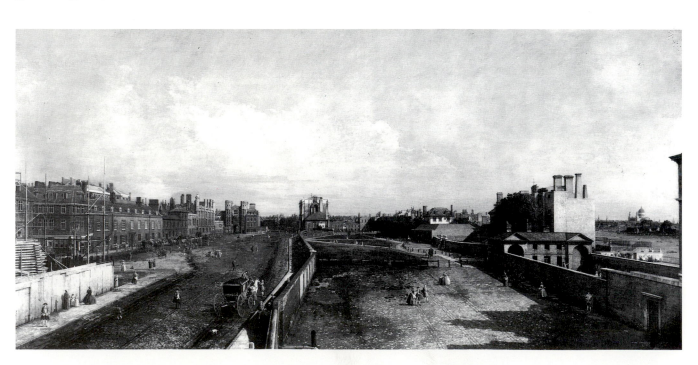

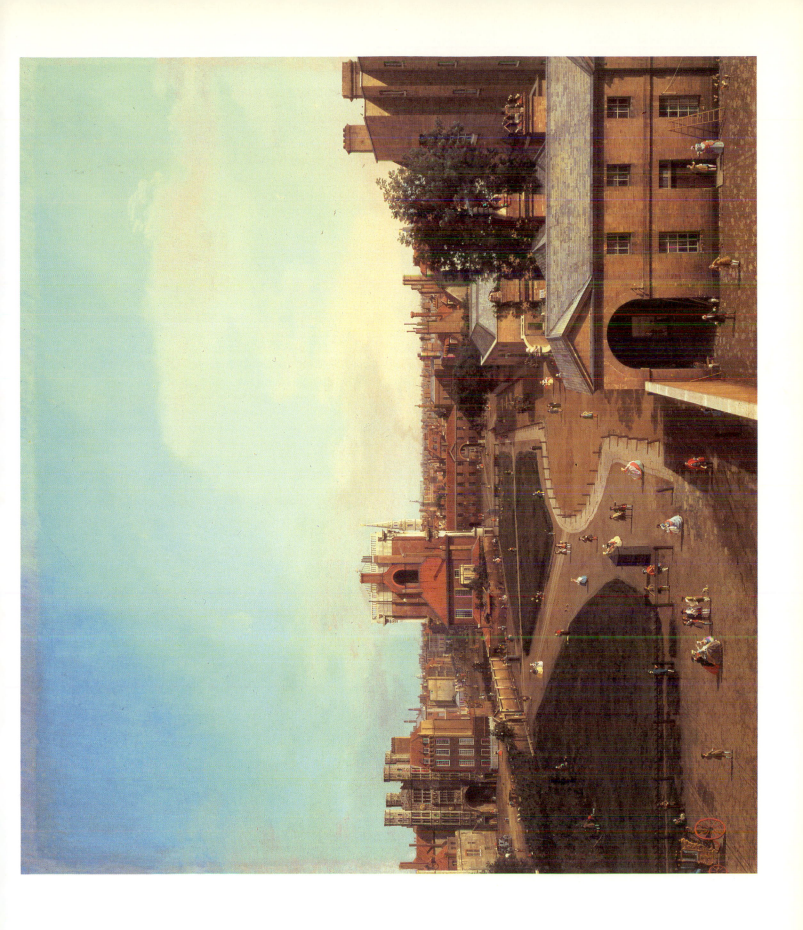

London: the Thames and the City of London from Richmond House

1747. Oil on canvas, 105 x 117.5 cm. Trustees of Goodwood House, West Sussex

The majestic sweep of the river, leading to a skyline dominated by St Paul's Cathedral, forms the focus of this canvas, which was made as a companion picture for Plate 30. Canaletto has succeeded in creating an extraordinary sense of spaciousness: with the combination of calm water, bright clear morning light and an untroubled sky, he has brought to the London scene some of that clarity of vision, and pleasure in celebrating the attractions of a great city that he had earlier applied to Venice.

The terraces in the foreground belong to Richmond House and, at the left, Montagu House. The figures on them parade, converse, and in a leisurely manner watch the spectacle of the river in the sunshine. While a number of smaller boats skull about on it, two larger decorated barges belonging to the City of London, make their way upstream. A related drawing of the scene (Fig. 29) shows a broader view, with far more traffic on the Thames.

The vertical emphases of the church spires, chimneys at the left, and mooring posts in the foreground, all carefully anchor and balance the composition, which is principally ordered by the horizon and gentle diagonals of the river bank.

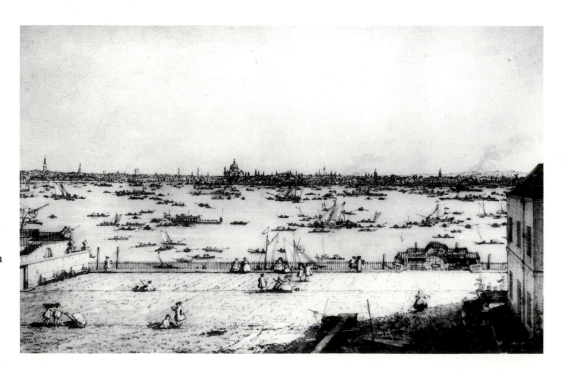

Fig. 29
London: the Thames and the City of London from the Terrace of Richmond House
Probably 1747. Pen and ink with wash on paper, 33.7 x 54 cm.
The Earl of Onslow

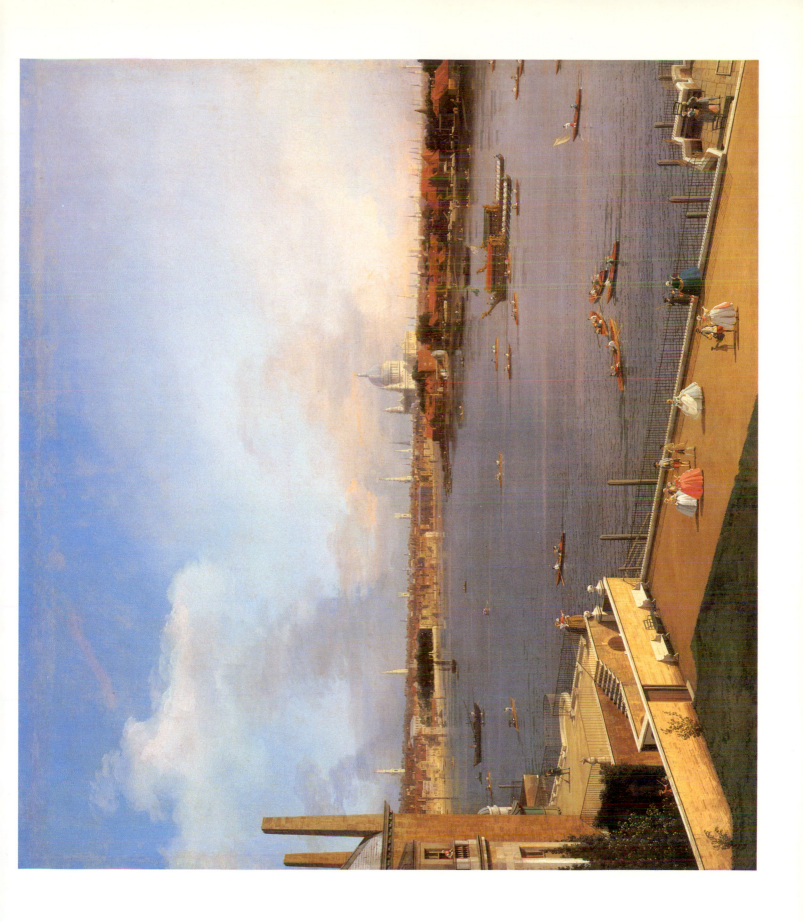

Warwick Castle: the South Front

1748. Oil on canvas, 75 x 120.5 cm. Thyssen-Bornemisza Collection, Madrid

Canaletto made five paintings of Warwick Castle, more than he was to paint of any other English building. He was commissioned to depict the subject by its owner Francis Greville, Lord Brooke, who became Earl of Warwick in 1759. The dates of payments suggest that Canaletto journeyed at least twice to Warwick, in 1748-9 and 1752. This work, probably painted in London, seems to be related to the earlier visit.

The building is viewed from Castle Meadow, with the Castle Mound at the left and at the right a view of the town. On the River Avon in the foreground is a Venetian-style pleasure boat: this apparently incongruous detail may be explained by the fact that Lord Brooke had visited Venice and is know to have owned a decorated boat.

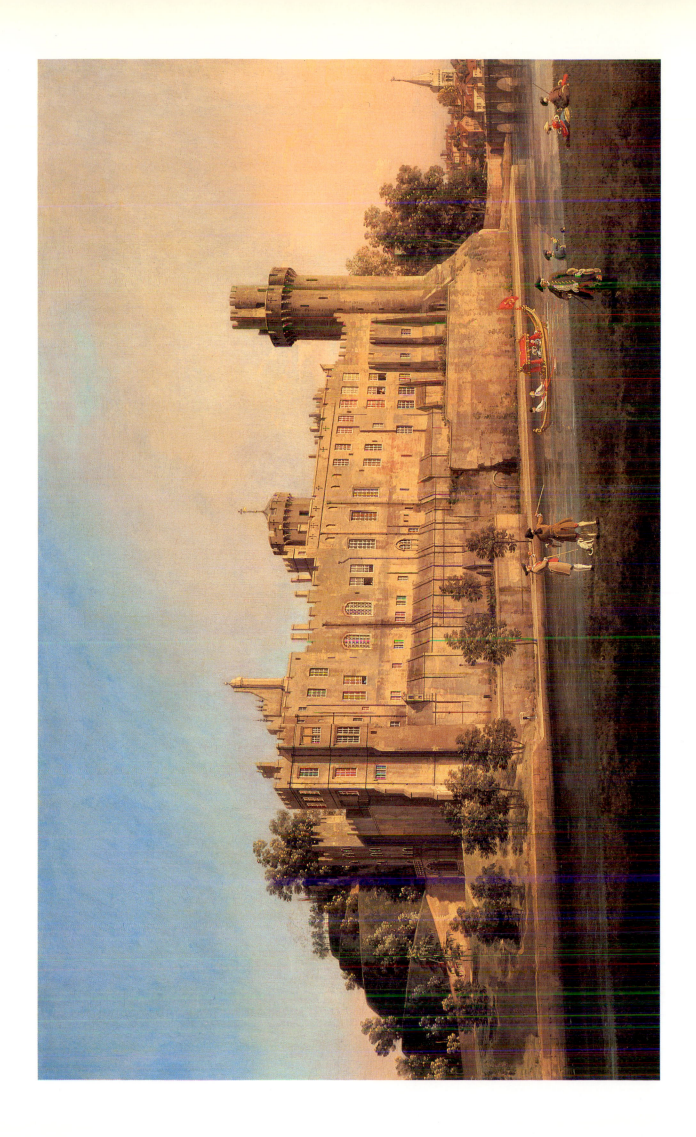

33

London: the Old Horse Guards from St James's Park

1749. Oil on canvas, 117 x 236 cm. Tate Gallery, London (Sir Andrew Lloyd Webber Art Foundation)

The Old Horse Guards building at the centre of this work was demolished shortly after Canaletto painted it, and replaced by the New Horse Guards, which was completed in 1753. It has convincingly been suggested that part of Canaletto's motivation in producing the picture was to record the view of a historic site prior to its alteration. He was to display similar instincts on other occasions (see Plate 30).

This is, however, far from simply being a work of antiquarian interest. The painter has filled the scene with a variety of figures ranging from the regiment of the King's Life Guard's who drill in the background to the footmen at the right who beat a carpet, near to the entrance to Downing Street.

The painting seems to be the one the artist publicly exhibited at his lodgings, and publicized in the *Daily Advertiser* of 25 July 1749:

SIGNOR CANALETTO hereby invites any Gentlemen that will be pleased to come to his House, to see a picture done by him, being A View of St James' Park, which he hopes may in some Measure deserve their Approbation. The said View may be seen from Nine in the Morning till Three in the Afternoon, and from Four till Seven in the Evening, for the Space of fifteen days from the Publication of this Advertizement. He lodges at Mr Richard Wigan's, Cabinet-Maker, in Silver-Street, Golden Square.

By 1756 it was recorded as being in the collection of Lord Radnor, who described it as 'I think the most capital picture I ever saw of that master [Canaletto]'.

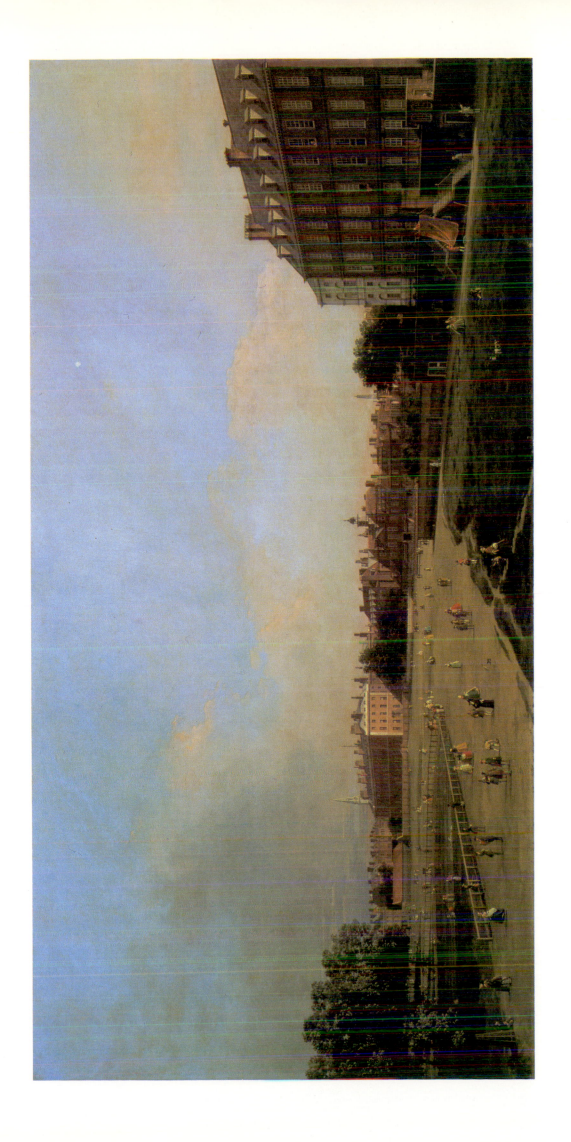

London: the Old Horse Guards and Banqueting Hall, from St James's Park

1749. Oil on canvas, 45.5 x 76 cm. Private collection

This work shows the same subject as Plate 33, but from a closer and more frontal viewpoint. To the right, behind Old Horse Guards on the far side of Whitehall, is Inigo Jones' Banqueting Hall. Near to it and almost hidden by the screen of trees can be seen part of the Holbein Gate.

The painting is related to a working drawing in Canaletto's Accademia sketchbook (Fig. 30). The inscriptions on this sheet reveal a great deal about how the artist made notations in the open air in front of the buildings, which later could be converted into visual equivalents in the studio. He has, for example, noted above the capitals of the columns of the Banqueting House *ionico* and *composito* (referring to the ionic and composite orders), and on the roof of the building the letter *P*, which stands for *piombo*, or lead. The sketch seems to have been made quite rapidly and is clearly signed at the lower right – Canaletto Veneziano (Canaletto the Venetian).

Fig. 30
London: the Old Horse Guards and the Banqueting Hall, Whitehall
1749. Pen and ink on paper, 11.4 x 21.7 cm. Accademia, Venice

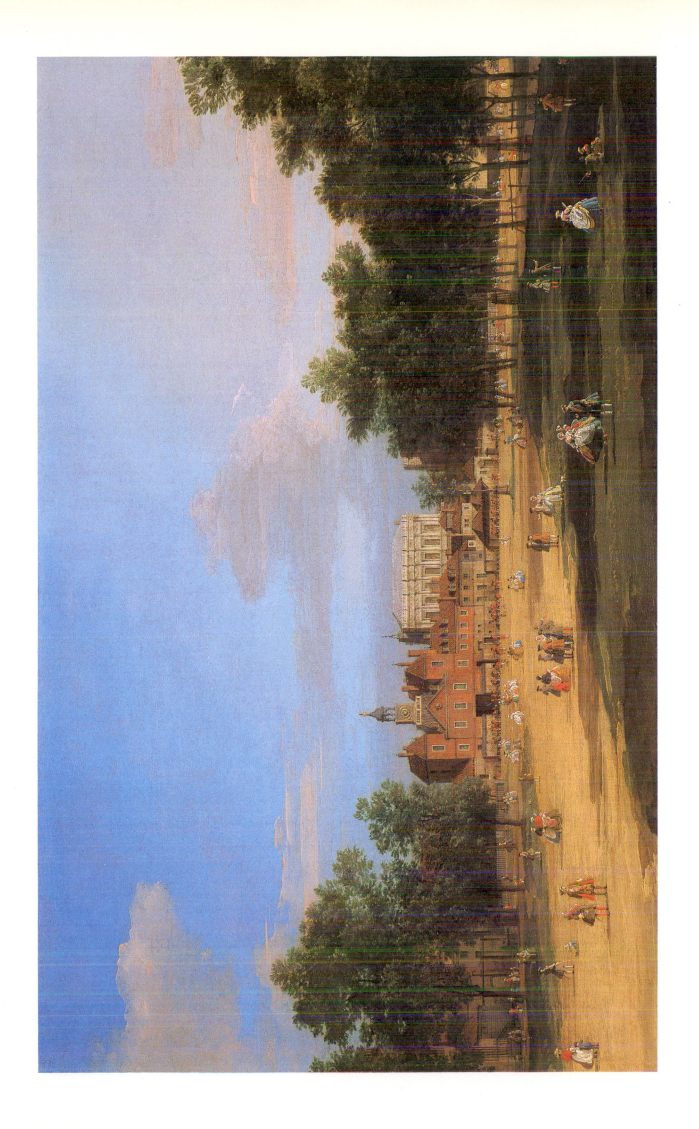

35 London: Westminster Abbey, with a Procession of Knights of the Bath

1749. Oil on canvas, 99 x 101.5 cm. Dean and Chapter of Westminster Abbey, London

The Order of the Bath is one of the oldest English chivalric orders; it is thought to have been founded in 1399. Canaletto here has painted the procession of newly installed Knights of the Order from Westminster Abbey to the House of Lords which took place on 20 June 1749. He was commissioned to paint the picture by Joseph Wilcocks, Dean of Westminster, and it has remained since it was executed in the Deanery.

The knights have emerged from the west end of the Abbey and walk round past St Margaret's church, beyond which can be seen the roof of Westminster Hall. The Abbey is shown after its recent restoration and the construction of the two west towers, an undertaking which was carried out by the architects Nicholas Hawksmoor and Sir Christopher Wren, and the picture in many ways acts as much as a commemoration of their achievements, as of the ceremony.

Canaletto may have based his depiction of the event on descriptions, rather than actually having witnessed it: the resplendent knights are impressive, but they are arather stilted in arrangement, and their scale in relation to the architecture is not completely convincing.

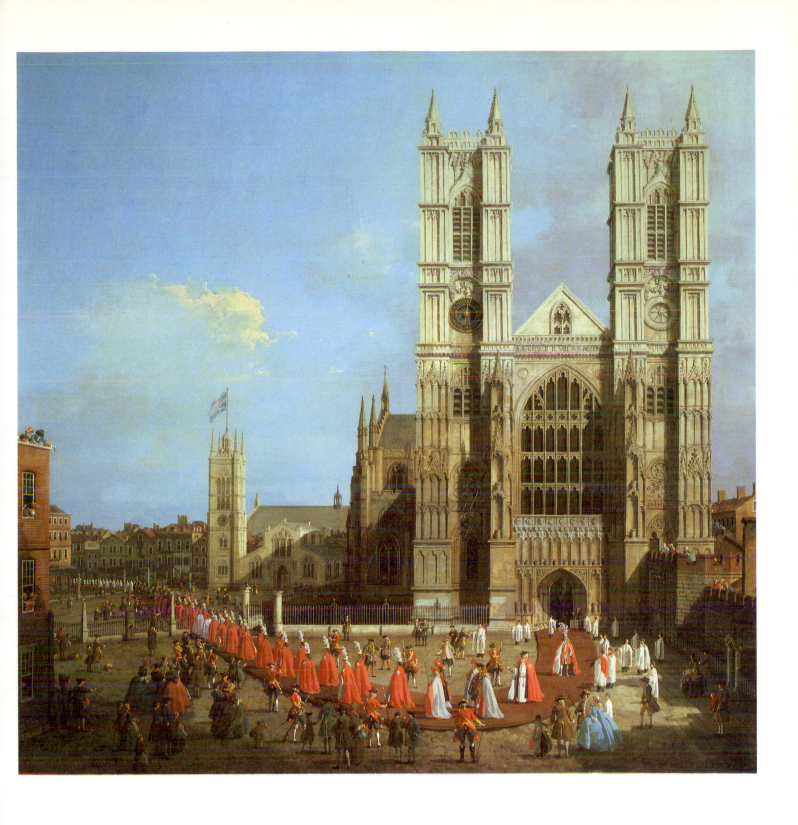

1752. Oil on canvas, 73 x 122 cm. City Museum and Art Gallery, Birmingham

This view was commissioned by Lord Brooke, and until relatively recently remained in Warwick Castle. Canaletto contrasts the towering medieval battlements with a view of a few of the houses in the town at the left. The brilliant blue sky seems to be based on his experience of a southern climate, rather than English conditions. The visitors, servants and dogs in the foreground, effectively provide anecdotal interest, while the bright colours of their clothes act as a foil for the dull stonework of the building.

Canaletto also made a companion picture for the painting (Fig. 31), which perfectly complements it, as a depiction of the same side of the castle from the interior lawn. He has filled this canvas, from left to right, with Guy's Tower, the Clock Tower over the entrace gate, and Caesar's Tower.

Fig. 31
Warwick Castle: the East Front from the Courtyard
1748-9. Oil on canvas, 75 x 122 cm.
City Museum and Art Gallery, Birmingham

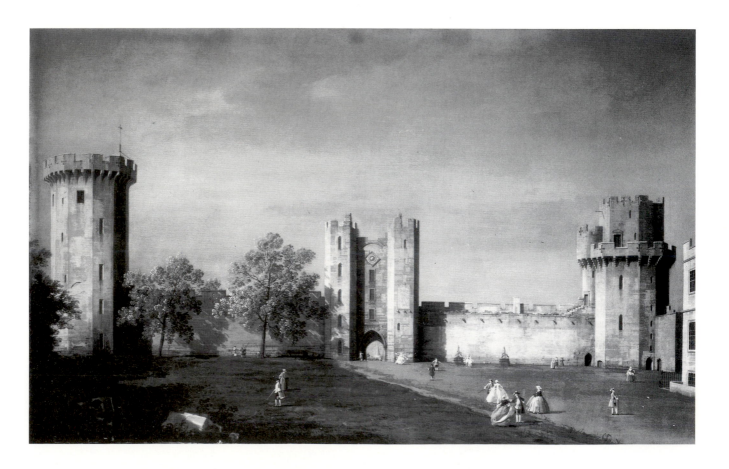

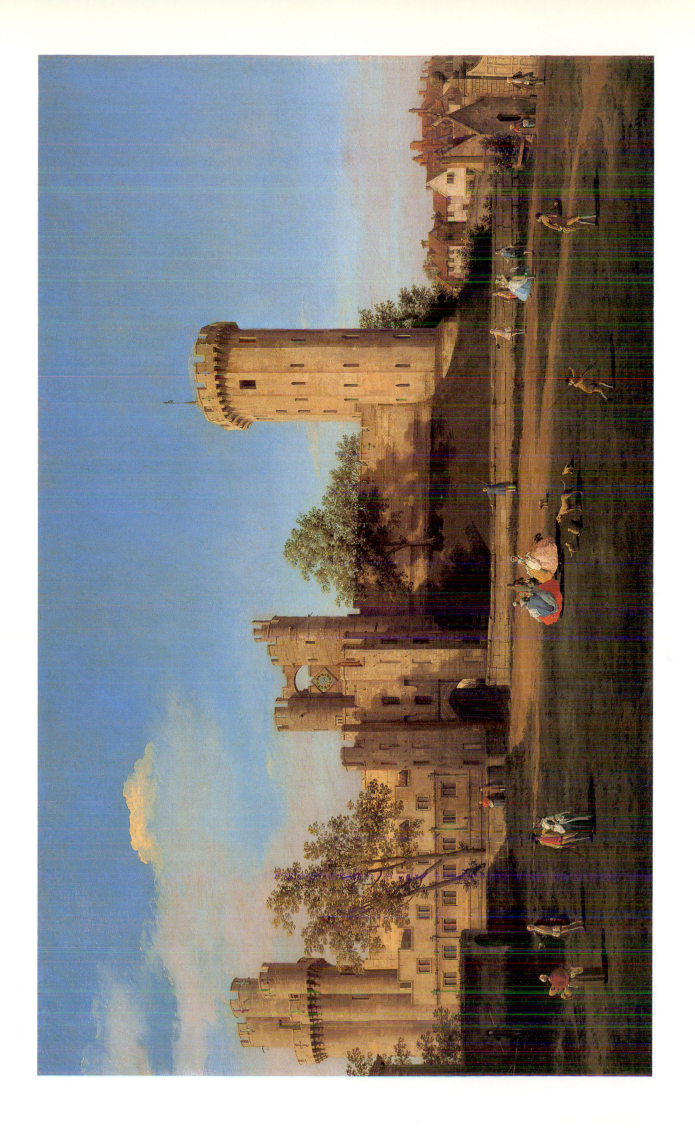

London: Northumberland House

1752. Oil on canvas, 84 x 137 cm. Duke of Northumberland

Northumberland House at Charing Cross was the London residence of the Earl of Northumberland, who commissioned Canaletto to paint this picture. The house had recently been inherited and refashioned, and Canaletto concentrated his attention on its elegant and mellow façade. The impressive appearance of the building is enhanced by its towers which are sumounted by gilt weather vanes, and the row of obelisks that support lamps on the pavement before it. The house was eventually demolished in 1873, making way for Northumberland Avenue, and the lion above the doorway was then moved to Syon House in Isleworth, Middlesex, where it can still be seen.

Canaletto created far more than just a celebration of a particular building, however; he also provides us with an invaluable record of its surroundings, and a vivid impression of the capital coming to life early in the morning. To the right is the statue of Charles I by Hubert Le Sueur (*c*1595-*c*1650) that now stands at the entrance of Whitehall from Trafalgar Square, and at the left is the entrance to the Strand and the Golden Cross Inn, which has a sign standing in front of it.

The painting was much copied and engravings were made after it; as a result of the distribution of these copies, it was to have a significant influence on the work of English artists who depicted urban scenes.

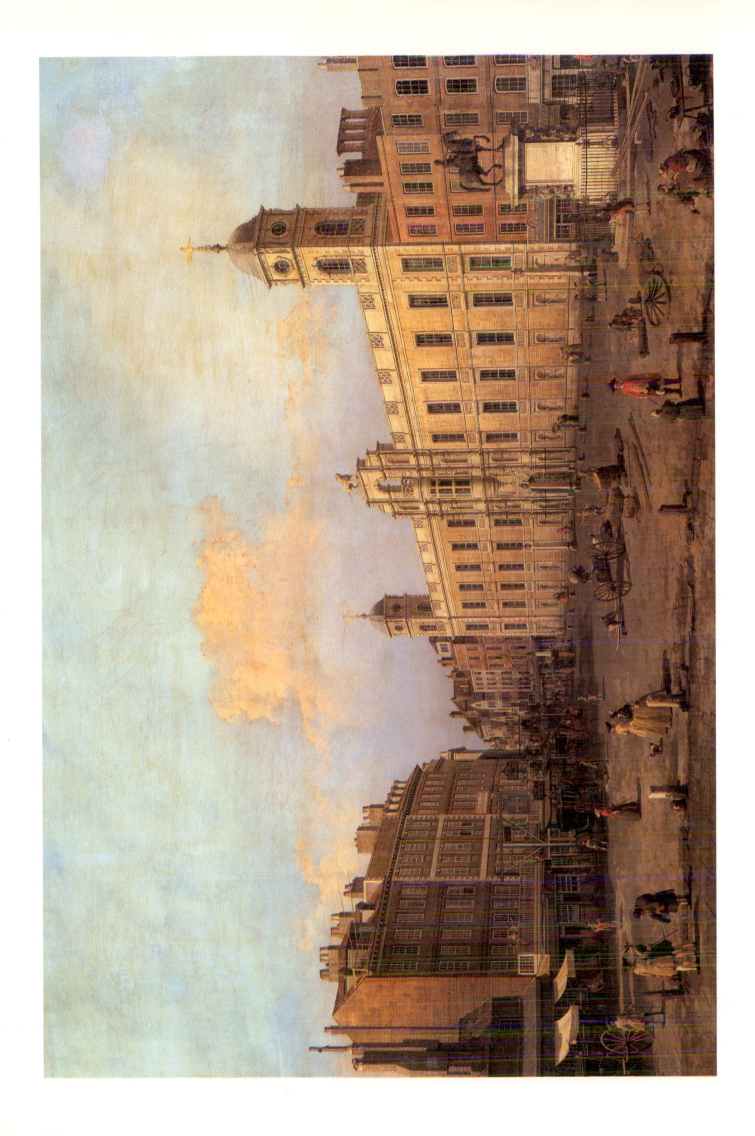

London: Greenwich Hospital from the North Bank of the Thames

*c*1753. Oil on canvas, 66 x 112.5 cm. National Maritime Museum, London

The Royal Hospital at Greenwich was completed in 1752, over half a century after it was begun. Canaletto painted this depiction of it soon afterwards. It shows the view, which has altered little, through the centre of the hospital complex to the Queen's House, and on towards the Royal Observatory at the top of the hill beyond.

Canaletto has created a slightly 'wide angle' effect by combining what can be seen of the hospital from two separate viewpoints which are set a little way apart on the near side of the Thames. He has slightly broken the potential symmetry of the composition by studying the buildings from a little left of centre. In addition, the monotony of the river is relieved by the considerable variety of craft that is travelling up and down it, and also by the unrelenting verticals and horizontals of the design which are countered by the bold diagonal of the mast of the ship grounded at the right.

The river and architecture were established first by the artist, and the boats then painted over the top; it is just possible to see the buildings through the sails of the boat to the left of the centre of the picture.

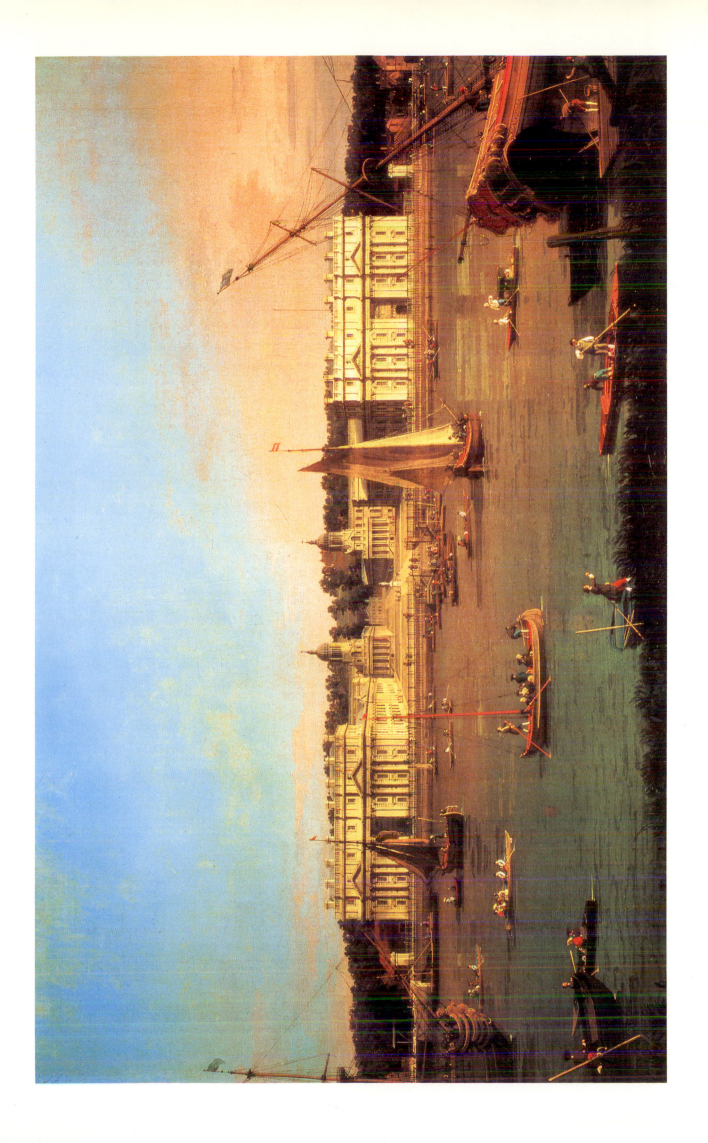

1754. Oil on canvas, 46 x 75.5 cm. National Gallery, London

In the eighteenth century there were two main pleasure gardens in London – at Vauxhall and Ranelagh. The latter, which was situated in Chelsea, was regarded as the more respectable. Among its attractions was this Rotunda, which served as a public venue for various forms of entertainment. It became a fashionable place to dine, converse and listen to music, and Mozart performed there in 1764. Canaletto shows numerous groups of elegantly dressed figures either gossiping and creating their own amusement, or concentrating on the orchestra at the left.

This picture was painted for Thomas Hollis, a significant patron of Canaletto, who owned nine works by him (see also Plate 40). On the reverse it bears an inscription, which when translated from the Italian reads 'Made in the year 1754 in London for the first and last time with the utmost care at the request of Mr. Hollis, my most esteemed patron – Antonio del Canal, called Canaletto.' It may well be the case that Hollis requested that the canvas be inscribed in this way in order to certify its authenticity.

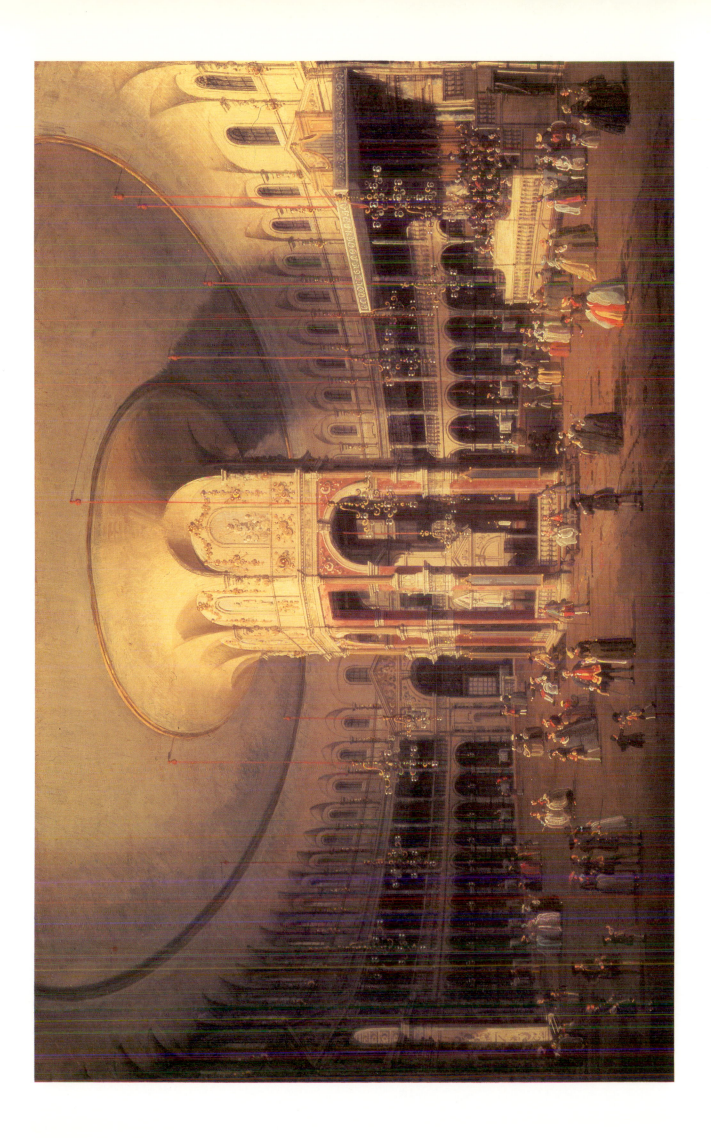

1754. Oil on canvas, 48.8 x 76.7 cm. Dulwich Picture Gallery, London

This bridge was paid for in 1747 by the Member of Parliament, Samuel Dicker, whose house is among the buildings on the far bank of the Thames, at the left. The view Canaletto has chosen shows the river from the Middlesex, or north side, looking upstream. He has peppered the scene with naturalistic details and human incident: a storm cloud with sheeting rain effectively contrasts with the white latticed wood of the bridge, over which an impressive carriage is drawn; in the foreground the mast of a boat has been lowered so it can travel beneath its arches, and a seated artist, who must be Canaletto himself, is depicted.

Old Walton Bridge was painted for Thomas Hollis; it bears the same inscription as that which appears on the reverse of Plate 39. According to an old catalogue of the Hollis collection the three standing figures to the right of the artist are Hollis himself, his friend Thomas Brand who inherited the painting, and his Italian servant Francesco Giovannini; the little animal between them is Hollis's pet dog, Malta.

Canaletto painted a second and much larger version of the scene for Samuel Dicker, in the following year (Fig. 32). This reinterpretation from a different viewpoint includes the ornate approaches to the bridge. It seems that in both works the artist did not strictly describe its appearance; a comparison with old plans of the structure shows he deviated from reality for picturesque effect.

Fig. 32
Old Walton Bridge
1755. Pen and brown ink
and grey wash, 29 x 63 cm.
Yale Center for British
Art, New Haven, CT

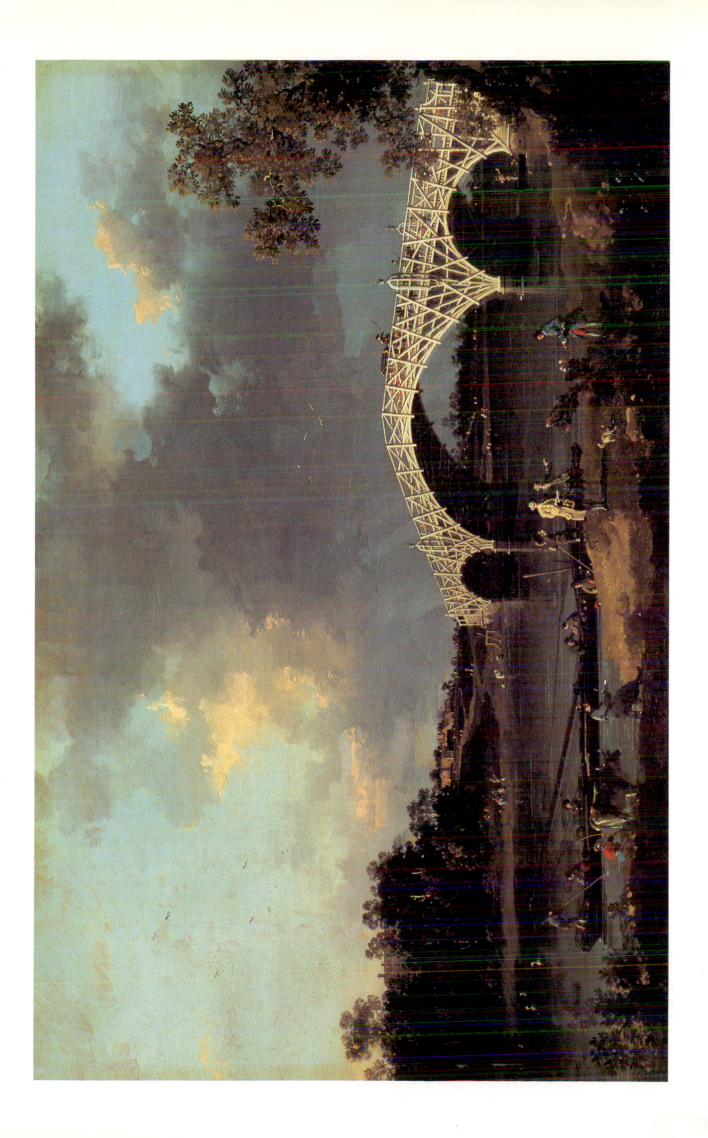

*c*1754. Oil on canvas, 61.5 x 107.5 cm. National Gallery, London

The college and its chapel are depicted as though seen from the east, across the river Thames. A number of the buildings near to them seem to have been invented by Canaletto, and the scene as a whole, which follows a composition established in a drawing by the artist, therefore appears to be a subtle *capriccio*. Canaletto had visited and painted nearby Windsor Castle in 1747, and could then have made a study of the college which he later chose to integrate with other features.

The view may not be an accurate record, but it is carefully composed, with the tree framing it at the left and a darkened foreground leading the eye of the viewer on into the middle-distance. The figures who fish, punt and stroll by the water effectively animate the scene.

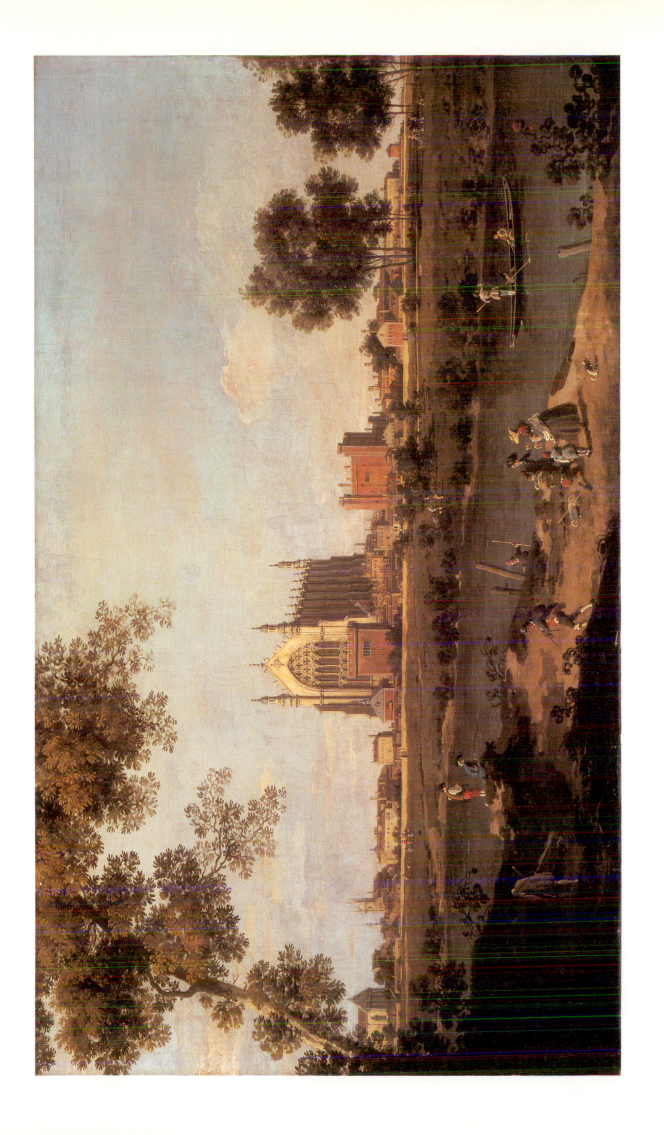

Capriccio: River Landscape with a Column, a Ruined Roman Arch, and Reminiscences of England

*c*1754. Oil on canvas, 132 x 104 cm. National Gallery of Art, Washington DC

This is another fine example of the type of *capricci* Canaletto executed during his sojourn in England. It is one of a group of paintings known as the 'Lovelace Canalettos', so-called because they were sold in 1937 by the Earl of Lovelace. He had inherited them from Lord King who probably acquired them in the eighteenth century for his home, Ockham Place in Surrey.

This work is an ingenious combination of Italian and English influences – a fitting project for Canaletto to work on prior to his final return to Venice, after having spent nearly a decade in England. The general disposition of the hilly landscape and the vegetation appear English, and a bridge inspired by Westminster Bridge has been placed in the middle distance (compare it with Plate 28). The Corinthian column, however, decorated with an escutcheon and surmounted by a statue of a saint, and the triumphal arch, are clearly Italianate. The juxtaposition of these two sets of references cleverly and subtly encourages you to question what is real, and what is imagined.

San Marco: the Interior

*c*1755. Oil on canvas, 36.5 x 33.5 cm. Royal Collection

Canaletto rarely depicted interiors; this is one of only two paintings by him of the inside of San Marco (see also Fig. 35). It was probably executed soon after he returned from England to Venice, and was painted as a companion picture for a depiction of the Scala dei Giganti in the courtyard of the Palazzo Ducale.

Canaletto painted a view looking towards the rood screen, decorated with garlands at the east end of the church, from a point near to the entrance. The choristers to the right of the screen reappear in the foreground of other works by the artist (see Plate 48). Beneath the arcade to the left of the nave a priest can be seen officiating at a small altar. Canaletto has effectively captured that most elusive of effects – the way the little light which enters the building plays upon the extensive mosaic decoration above. Many people are shown at prayer, and two small dogs cower in the right foreground.

Grand Canal: looking South-East from the Campo Santa Sophia to the Rialto Bridge

*c*1756. Oil on canvas, 119 x 185 cm. Gemäldegalerie, Berlin

This is one of four paintings, executed for Sigmund Streit, a German merchant who lived in Venice and Padua, and dates from Canaletto's return to Italy. Streit made a gift of much of his property to his old school in Berlin, and in 1763 compiled a catalogue of it which includes a description of the four Canalettos. He noted that the Palazzo Foscari which dominates the scene at the left was his home in Venice, and proceeded to discuss it in some detail, pointing out which rooms he used as his study and office, as well drawing attention to the presence of the chimney-sweep on the roof. Streit also described the ferry which crossed the canal, and the toll office for fish at the extreme right. Details such as these would have been of greater interest to residents of Venice than to visitors; the same could be said of the Campo di Rialto, a centre of commerce, which was the subject of another painting in the same group (Fig. 33). The artist depicted it as a market place for vegetables, household goods, furniture, and perhaps most interestingly paintings (at the far right).

Fig. 33
Campo di Rialto
*c*1756. Oil on canvas,
119 x 185 cm.
Gemäldegalerie, Berlin

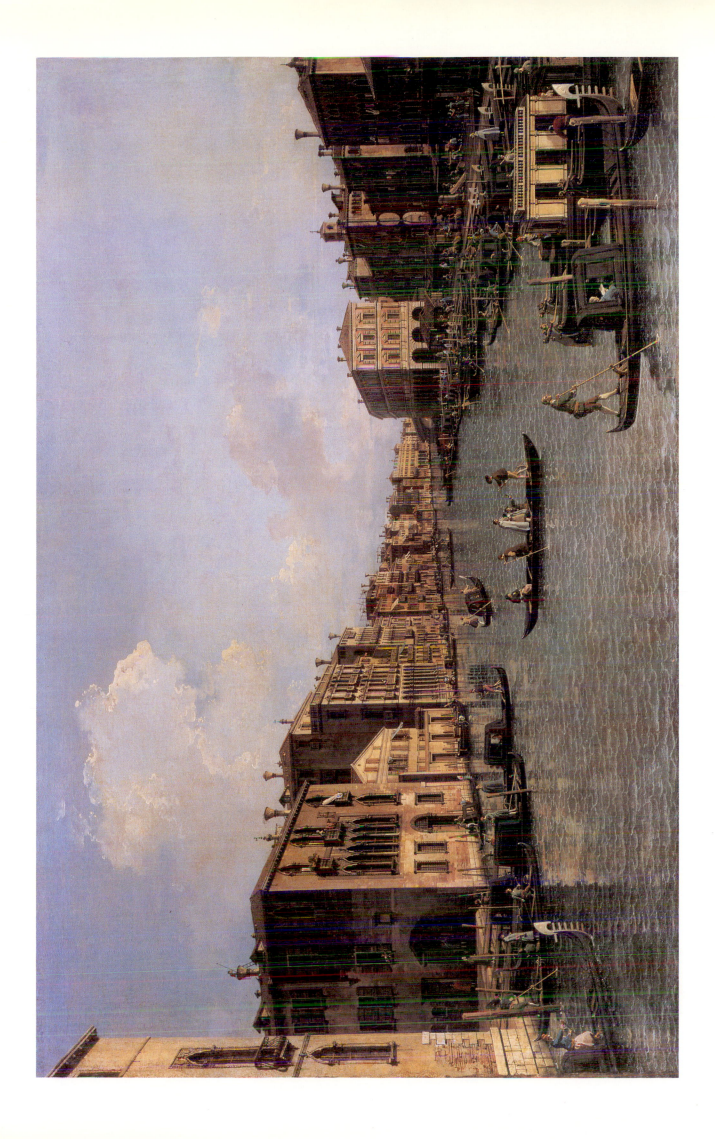

Piazza San Marco: looking South-West

1750s. Oil on canvas, 67.3 x 102 cm. Wadsworth Atheneum, Hartford, CT

Even in his later works Canaletto did not tire of ceaselessly experimenting and innovating. Here he shows a 'fish-eye' view of the Piazza San Marco, which may well have been plotted with the help of a lens. The distortion is such that we are allowed to see an impossibly wide panorama that stretches from the end of the Procuratie Vecchie at the right to the Palazzo Ducale and San Marco at the left.

It has been suggested that the artist was consciously displaying his ingenuity in such works (there is another important example in the Los Angeles County Museum of Art), in order to impress the Venetian Academy of Fine Art which he was seeking to join at the time.

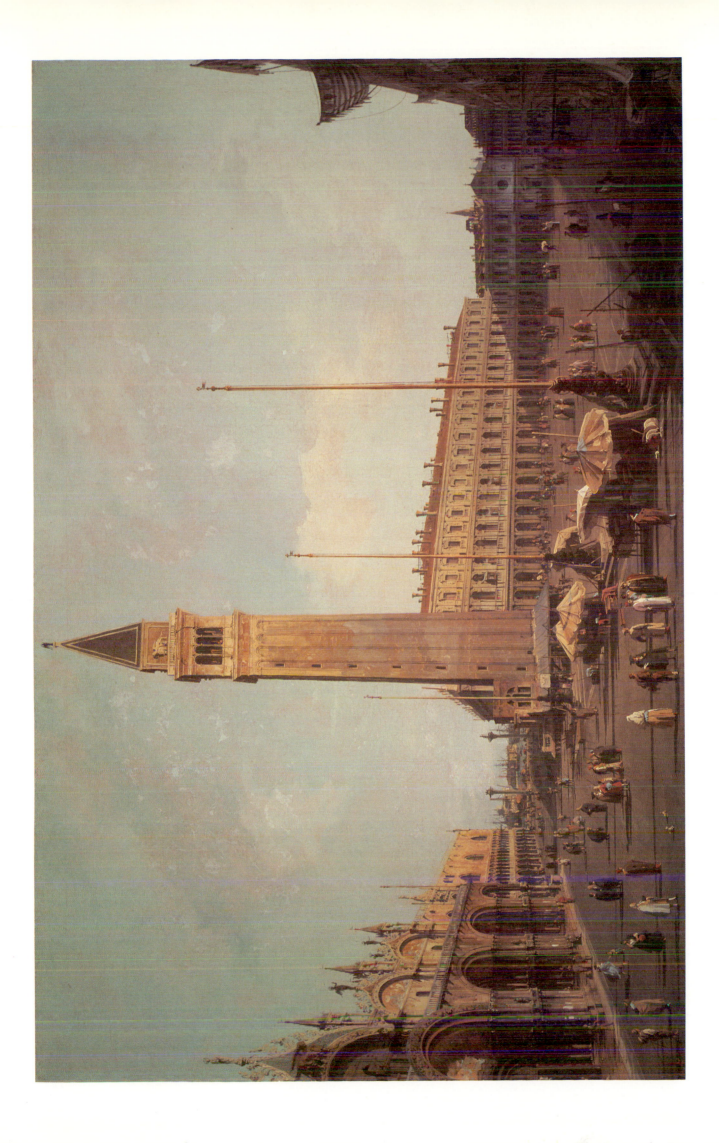

Piazza San Marco: looking East from the North-West Corner

*c*1760. Oil on canvas, 46.5 x 38 cm. National Gallery, London

Canaletto had earlier employed an arch to internally 'frame' a view in London (Plate 29). He here uses such a device in a Venetian context, and effectively contrasts the darkened foreground with the brilliantly lit Piazza, so drawing the viewer into the scene. The flagstaffs before San Marco have been omitted, allowing an uninterupted view of its façade.

The viewpoint complements that of the painting's companion picture (Plate 47), which is also in the National Gallery, London. Both pictures are painted in what has been called Canaletto's late 'calligraphic' style, in which he employs a shorthand of dots and curved lines in order to place details such as highlights on figures.

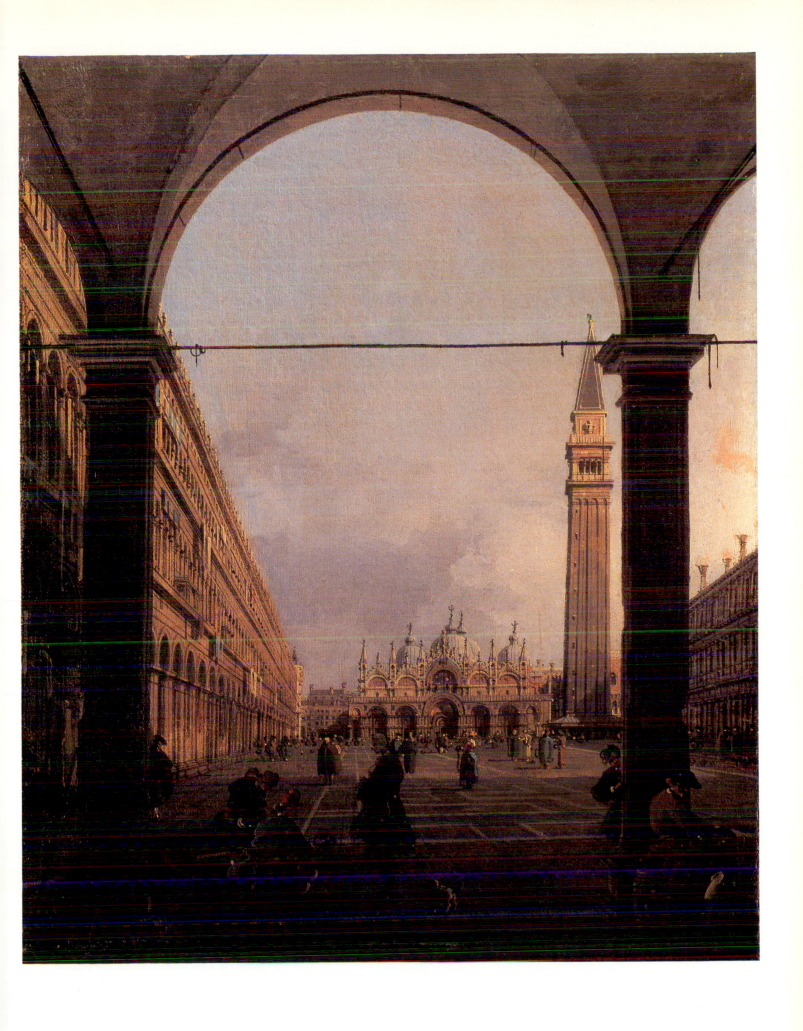

Piazza San Marco: looking East from the South-West Corner

*c*1760. Oil on canvas, 45 x 35 cm. National Gallery, London

Fig. 34
Piazza San Marco:
looking East from the
South-West Corner
*c*1760. Pen and ink
with wash on paper,
19 x 28.2 cm.
Royal Collection

The Campanile and San Marco are here seen from beneath the colonnade of the Procuratie Nuove, but it is not these architectural features which first draw your attention to the picture; it is more likely to be the figures in the foreground. Two seated men converse, while a third who stands to the right of them, holding a coffee cup, listens. He has presumably wandered from the nearby, although unseen, Café Florian, a famous centre of social life, which had been founded in 1720, and is still open.

A particularly attractive contemporary drawing, which can be associated with the composition (Fig. 34), shows the view extending some way towards the left, so that it is possible to see the Torre dell'Orologio. This worked up sketch probably preceded the painting and a group of other related works by Canaletto.

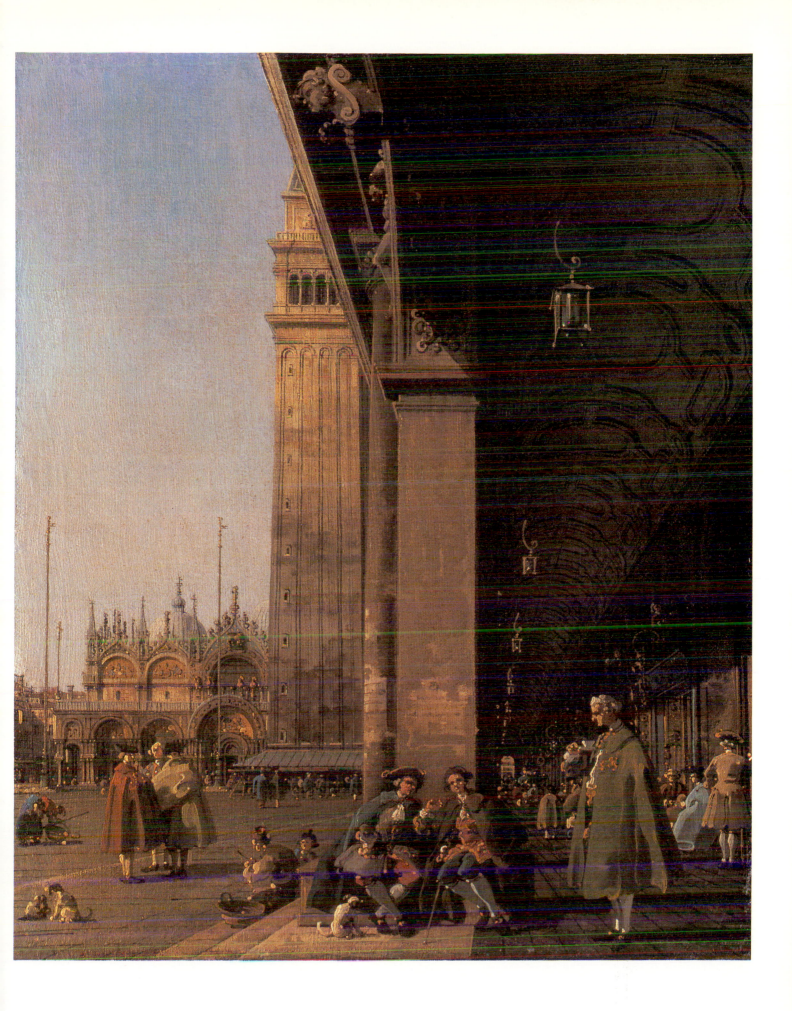

San Marco: the Crossing and North Transept, with Musicians Singing

1766. Pen and ink with washes, 47 x 36 cm. Kunsthalle, Hamburg

Fig. 35
San Marco: (an
evening service)
*c*1730. Oil on canvas,
28.6 x 19.7 cm.
Royal Collection

'I Zuane Antonio da Canal, made the present drawing of the musicians who sing in the ducal church of San Marco at the age of 68, without spectacles, in the year 1766.' This inscription, at the bottom of the sheet, seems to indicate the artist's defiance in the face of oncoming old age, and the work itself, which is his last dated picture, certainly illustrates no lessening of his skills as a draughtsman.

He had first recorded a similar view of the interior of the church in oil, over thirty years earlier (Fig. 35). In the painting Canaletto showed it thronged with people, in contrast to the drawing where he has concentrated on the careful placement of a few legible figures. In the drawing the choristers can be seen enthusiastically following the music in the enormous book which is propped up before them, while below a beggar is seated beside an altar, and to the left a kneeling man holding a rosary performs his devotions. Close to him a little dog – a by now indispensible detail in Canaletto's works – listens to the music.

The artist died two years later, but he was not sufficiently revered to be buried in a church as magnificent as this. He was instead interred in the more modest surroundings of San Lio, where he had been baptized.

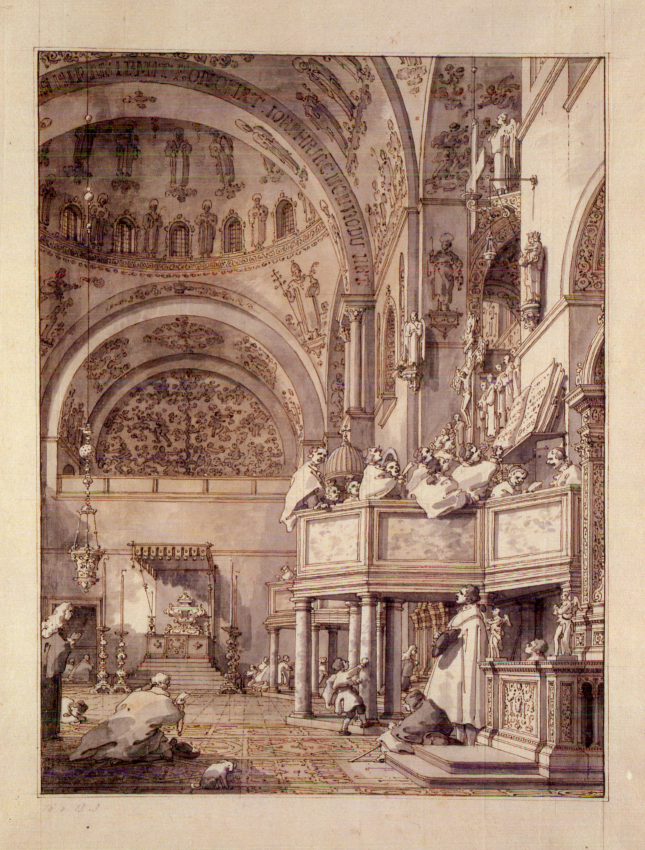

Io Zuane Antonio da Canal, Hò fatto il presente disegnio delli Musici che Canta nella Chiesa Ducal di S. Marco in Venezia, in età de Anni 68 Cénzza Ochiali, L'anno 1766.

BONNARD
Julian Bell

PHAIDON

CUBISM
Philip Cooper

PHAIDON

HOLBEIN
Helen Langdon

PHAIDON

GAINSBOROUGH
Nicola Kalinsky

PHAIDON

IMPRESSIONISM
Mark Powell-Jones

PHAIDON

ITALIAN
RENAISSANCE
PAINTING
Sara Elliott

PHAIDON

PICASSO
Roland Penrose

PHAIDON

WHISTLER
Frances Spalding

PHAIDON

PHAIDON COLOUR LIBRARY

Titles in the series